JOHN HEDGECOE'S
FIGURE & FORM
Photographing the Nude

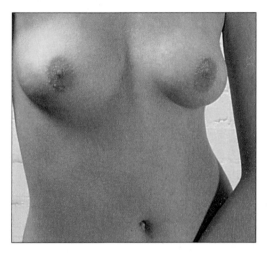

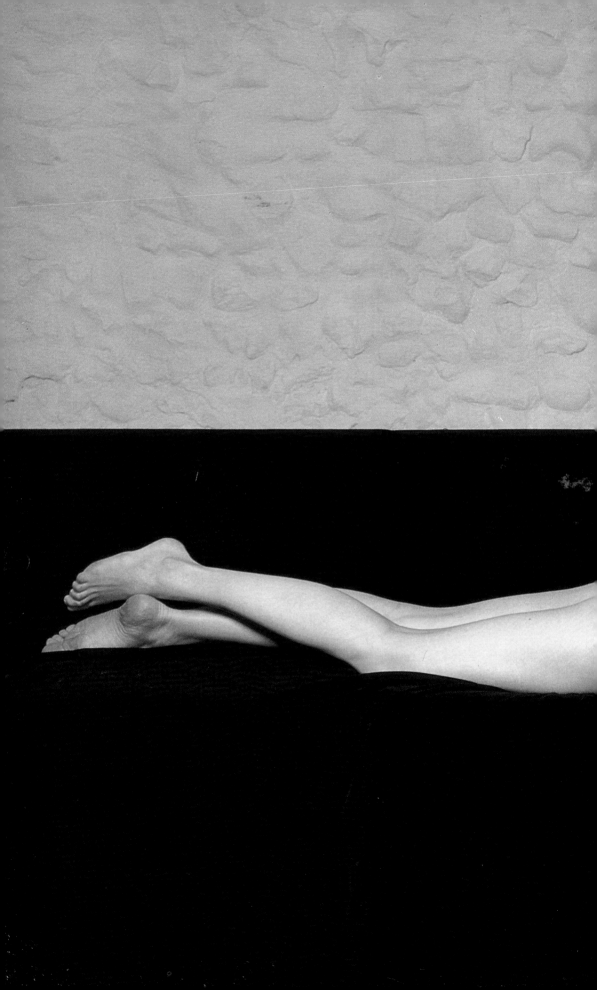

JOHN HEDGECOE'S
FIGURE & FORM
Photographing the Nude

C&B

First published in Great Britain in 1996
by Collins & Brown Limited
London House
Great Eastern Wharf
Parkgate Road
London SW11 4NQ

0691032441 1 3 5 7 9 8 6 4 2

British Library Cataloguing-in-Publication Data.
A catalogue record of this book
is available from the British Library

ISBN 1 85585 240 3 (hardback)
ISBN 1 85585 298 5 (paperback)

Conceived, edited and designed by Collins & Brown

Associate Writer: Jonathan Hilton
Editorial Assistant: Robin Gurdon
Art Director: Roger Bristow
Designed by: Phil Kay

Reproduction by Master Image, Singapore
Printed and bound in Italy by L.E.G.O. SpA, Vicenza

Contents

Introduction

THE PHOTOGRAPHIC depiction of the naked figure is a modern extension of an art form that has persisted since before the dawn of recorded history. The principal difference between photography and other media is that the photograph, rather than being symbolic or representational in any way, is a frozen instant of reality. And it is for this reason – because you are showing a real person, in a vulnerable fashion, and in a contemporaneous time frame – that you owe a particular duty of consideration and respect when photographing the human figure.

Approaches to the subject

All of us probably feel at our most vulnerable standing exposed and naked – even more so when the other person present is clothed, a relative stranger, and is taking photographs. It will help

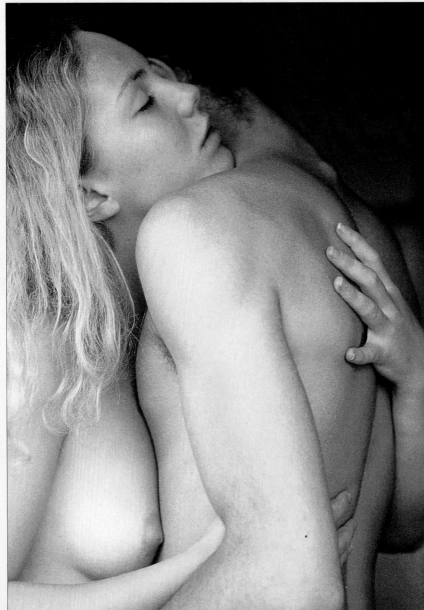

◁ **Couples**
If you intend to photograph a man and woman together, it is far better to use a couple who are used to working with each other. Two strangers thrown together for a photographic session are unlikely to be able to relax sufficiently with each other to make their responses seem genuine and unforced.

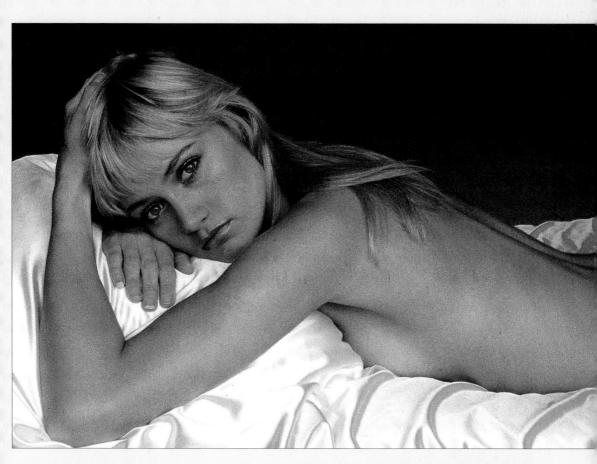

to bear this in mind when you are directing your subject on how he or she is to pose. Because, in fact, what you are asking for is not simply a pose – far more importantly, you will want that person to express, through body language, expressions, shape and form, the specific mood and atmosphere you want to capture on film. If you are working with professional figure models, then this task will be made very much easier for you. Always make sure though that it is clear who is controlling the session – an experienced model may try simply to run through a stock repertoire of poses.

It is most likely that you will, at least initially, be using acquaintances, friends, or members of your family as your models. All through the session, keep a conversation going. The more you talk, the more at ease you will start to feel with each other, and the more relaxed the atmosphere will become. Background music often helps to set the right mood – pick music that is appropriate to the type of pose and expression you want to elicit from your subject.

Gaining experience
If you don't feel that you can approach anybody you know and ask them to pose for you, or perhaps you simply have not got the right lighting equipment and accessories of your own, then one of the best ways of gaining experience in this subject area of photography is by joining a local camera club.

In this type of environment, you can take advantage of a pool of both equipment and experience, and you will probably find that the older hands are only too willing to offer advice and

△ **Suppressing a background**
In a studio you are limited to the types of background you can use. Often, therefore, you will want to suppress the surroundings completely by ensuring that there is a wide exposure difference between subject and the rest of the area you are shooting in.

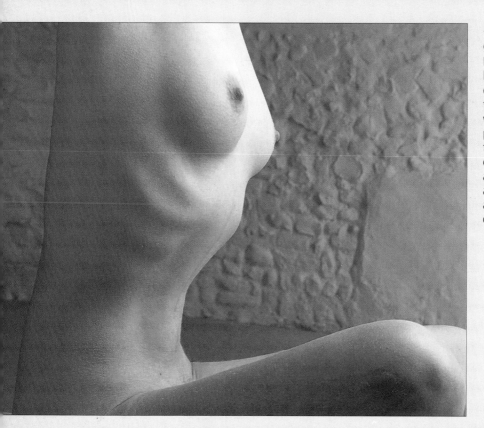

◁ **Altering the emphasis**
By cropping off the head of the model, either at the picture-taking stage or, later, when making the print, you can abstract the subject and concentrate the viewer's attention on such aspects of the model as form, shape, color, or texture.

encouragement to the newer members. The costs, too, of lights and modeling fees (which can be significant) will be shared out among all the members. Temperamentally, you may also prefer being just one of a crowd of photographers.

About this book
The first chapter of this book looks at a range of indoor picture-taking situations. There are two particular advantages to working either in a studio or a spare room of your home. First, you have complete control over lighting, excluding daylight altogether if you wish and relying on flash or tungsten units alone. Second, you have privacy, which is vitally important for nude photography. Different topics in this chapter take you through the types of problems and opportunities you may encounter with setting your lights, controlling the intensity and the quality of the illumination

to create a range of different styles, effects, moods, and atmospheres, and how to change the emphasis of a photograph to manipulate the viewer's response.

In the second chapter we look at outdoor photography, and the emphasis changes to dealing with the vagaries of daylight, using a range of settings and backgrounds to good effect, how to time your shot, framing and viewpoint, and recording subject movement.

The final two chapters of the book are designed to offer you just a sampling of ideas on how you could develop your own individual approach to photographing the human form, moving your work away from the more predictable type of picture by introducing an imaginative variation on some well-worked themes. A technical appendix and glossary of common photographic terms have also been included for the benefit of those new to the language of photography.

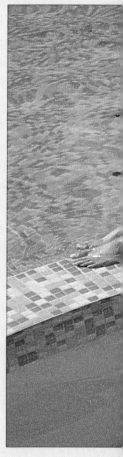

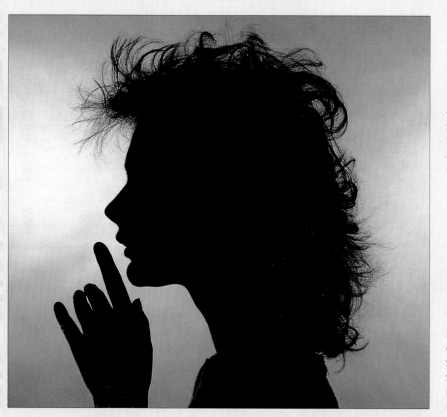

◁ **Silhouettes**
Arranging the lighting to create a silhouette is an excellent way to reduce the subject to its most basic element – shape. With all surface detail deleted, the figure can become a powerful graphic device.

▽ **Outdoor session**
For a successful outdoor photographic session, a location such as this swimming pool in a private home is ideal.

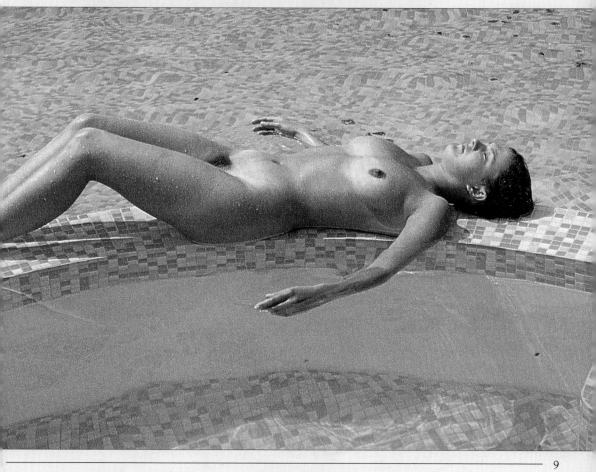

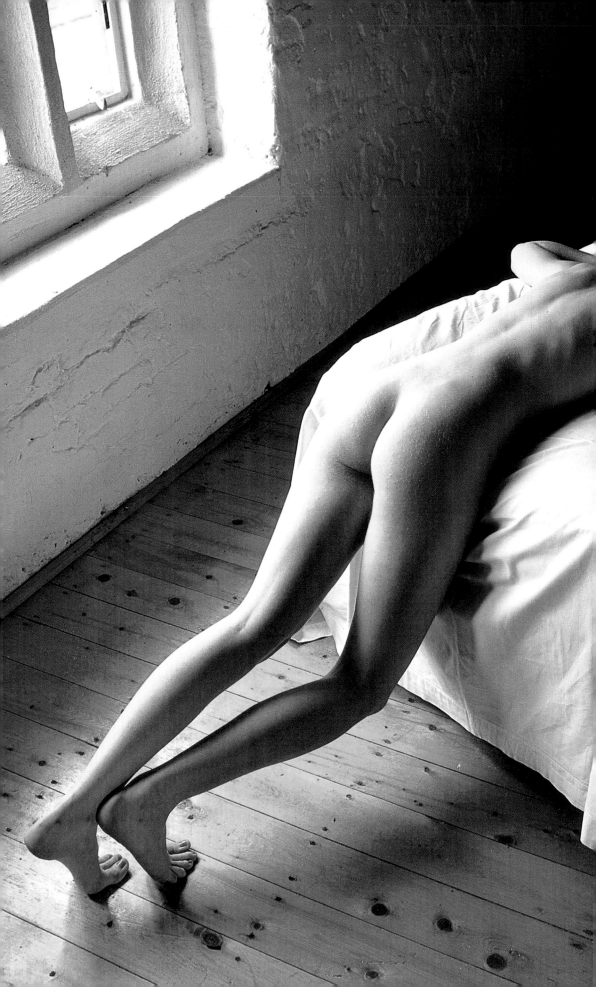

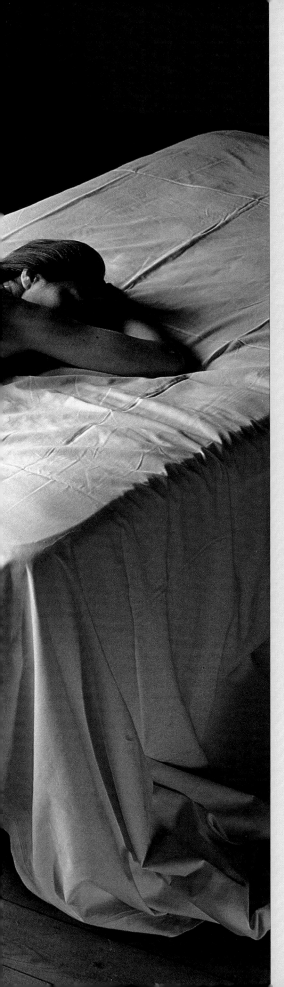

The Studio and Indoor Session

Working indoors, either in a purpose-equipped photographer's studio or in the more informal surroundings of your home, gives you the opportunity to exercise great control over both the quality and the intensity of the light falling on your subject. A domestic or studio setting also has additional advantages: it makes you independent of the weather and time-of-day factors, which often make natural-light photography outdoors impossible; and second, it provides privacy for both you and your subject.

What is a Studio?

MANY AMATEUR photographers find the term "studio" a little daunting, imagining a purpose-designed, cavernous room full of cameras, tripods, expensive lights, lighting stands, flats (for building sets), changing areas, and darkroom facilities. Certainly, some professional photographers do have facilities such as these, but for most "studio" photography any spare room in the house, even one that can be used only temporarily, will be fine.

For the overwhelming majority of the time, all that is needed – apart, of course, from a camera and tripod – is a basic lighting kit, comprising two or three flash units or tungsten lights (two floodlights and one spotlight), some lightweight lighting stands that allow a good range of height adjustments, and a few rolls of different colored background papers (as well as white and black paper when a neutral background is required). This equipment can be assembled or disassembled in a matter of minutes and stored away in a cupboard or closet when not in use.

Extras that you can add to this outfit if you eventually need them include softbox and snoot lighting attachments, to help control the quality of illumination reaching the subject, and an instant-picture Polaroid back for larger format cameras, for previewing results before shooting on regular film.

▽ **Wood-lined walls**
This rich-colored expanse of wood-lined wall would make an ideal backdrop. The texture of the wood, combined with the irregular pattern of knots, could become a real feature. When necessary, a large lens aperture could be used to limit depth of field (*see pp. 116–17*) and so prevent it from dominating the shot.

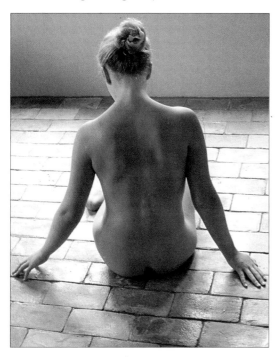

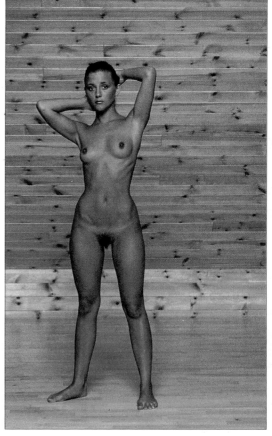

△ **Brick-built floor**
If you are lucky enough to have a room with an attractive feature already in place, such as this brick-built floor, then make the most of it by adopting a camera angle that shows it and the model to best advantage.

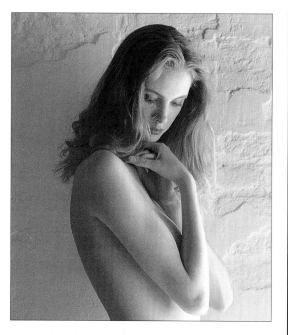

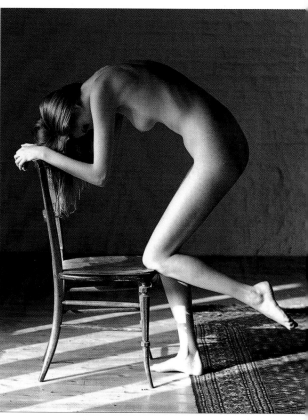

△ **Daylight studio area**
If you decide to work with daylight only, then your studio requirements are greatly simplified. All you need find is a suitable background and perhaps a few reflectors to minimize contrast.

△ **Black and white**
Photographing in black and white frees you from the worry of color casts if you mix natural daylight and studio or domestic tungsten in the same shot. Props, such as this simple country-style chair, are useful for your models to interact with.

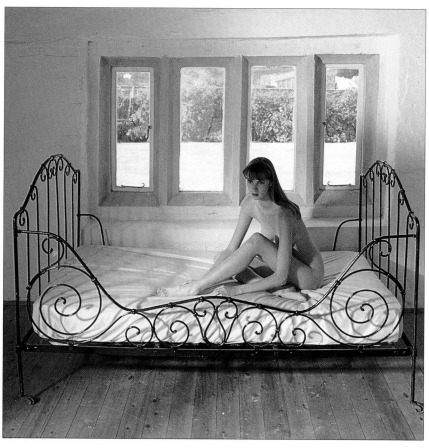

◁ **Special effects**
Colored gels, available in a wide range of colors, can be used over your lighting heads to create this type of eerie false-color effect. These cost very little to buy and you can cut them to fit any size light you are using.

Selecting a Pose

UNLESS BOTH the model and the photographer are experienced in their respective roles, a photography session can bring with it a certain degree of awkwardness and perhaps even embarrassment – for both parties.

Talk to the models while you set up your camera. Although you will be trying to get them to relax and enjoy their time in the studio, your principal job is to concentrate on looking for the best lighting angles and intensities, as well as directing the models into the poses that reveal shape and form at their most expressive. When setting up and shooting, work as quickly as you can, since some of the poses they will need to adopt may be uncomfortable.

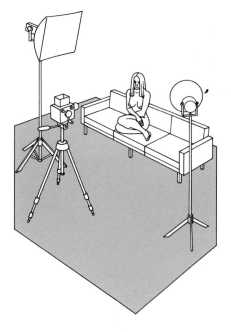

◁ **Flexible lighting**
If you want to take pictures quickly and spontaneously, you need a simple, flexible lighting set-up. The one used for all the pictures here consisted of a flash fitted with a softbox to the left of the camera pointing at the model and an undiffused flash to the right, using the wall as a reflector.

▽ **The first shots**
The session should begin with trying out ideas. Find props that help the model pose and lighting that reveals the best form.

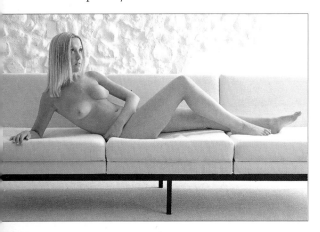

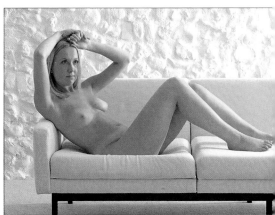

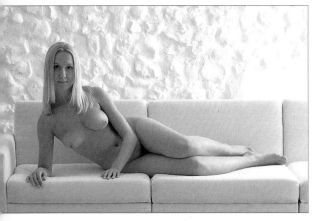

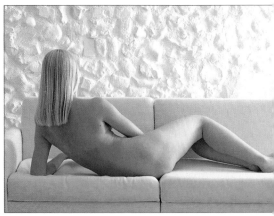

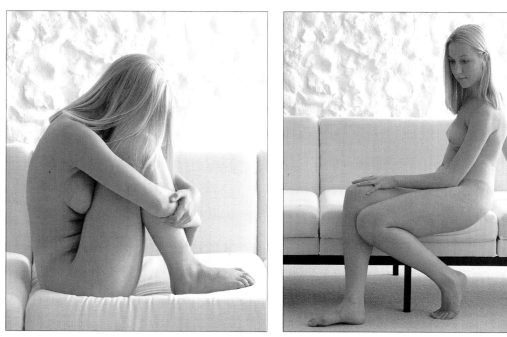

△ Building a rapport

As the session progresses, and you and the model become more used to each other, you should expect the model to become more responsive to your instructions. Don't let your concentration slip – care and attention to detail are critical. First, look for shape and form, and then mood and expression.

▷ A happy conclusion

A policy of encouraging and pushing the model to start expressing herself in front of the camera finally paid dividends. I was pleased with the way the session developed and she knew, too, that she had done a good job, which was a boost to her self-confidence.

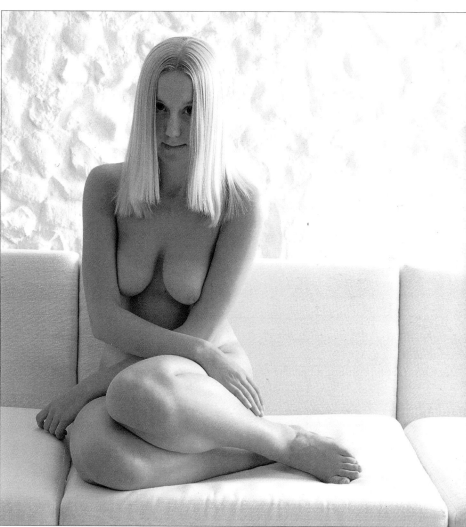

Building a Lighting Scheme

THE BEST way to learn about studio lighting, and to develop your own preferred styles of lighting, is to experiment. Use whatever lights you have available – portable flash, studio flash, or studio tungsten – at a range of distances from your subject, change the angle of lighting from shot to shot, and use a mixture of direct, bounced, and diffused lighting. But the best advice is always to use as few light sources as possible.

At least initially, take careful notes (or make simple diagrams) for each frame of film you shoot detailing the position and type of each light, where any reflectors were placed and what type they were (white or colored cardboard, for example, highly reflective or with more of a matt surface), and the lens apertures and shutter speeds employed. Also note the camera position in relation to the subject and lights and whether or not window light was a factor.

After processing and printing the results from each session, compare the prints with the notes or diagrams you made at the time of shooting. Make a mental note of the lighting that was most successful, not necessarily in terms simply of 'correct' overall exposure, but more in the quality and atmosphere it generated, even if the scene was perhaps generally over- or underlit.

At the conclusion of this exercise, hopefully you will not come to the conclusion that there is a single best type of lighting – one scheme used to the exclusion of all others soon becomes monotonous. Rather, try to develop a repertoire of different styles that you can apply to a range of subjects and situations in order to create, with a good degree of certainty, a specific lighting effect whenever the need arises.

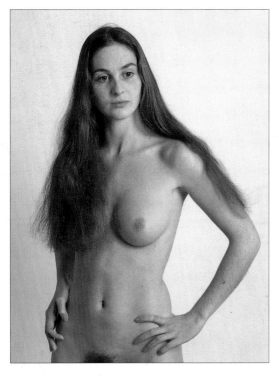

△ **Soft frontal lighting**
Place a light (here a softbox was added to the lighting head) in front of the subject. Move it nearer to and further away from the subject looking to see how highlights and shadows alter. The background was separately lit. Studio flash with built-in modeling lights allows you to preview results before taking a picture.

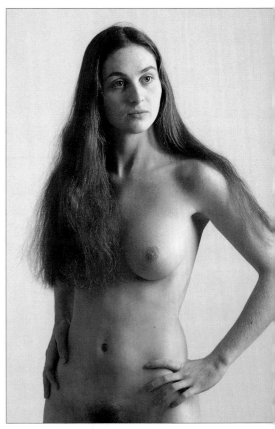

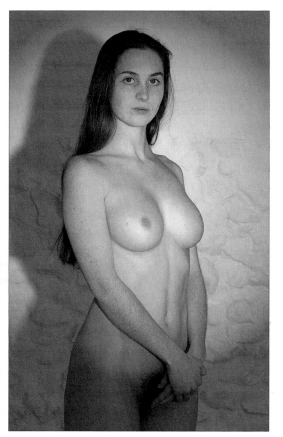

◁ ▽ **Undiffused flash**

To light these images, the previous lighting scheme was simplified. First, the softbox was removed to produce illumination with a harsher quality. Second, the background paper was dispensed with to reveal the rough-textured wall behind and the background light was also switched off. In the first image (*left*), the flash was placed directly in front of the subject. In the second (*below*), the light was moved well to the left of the camera position and the model moved closer to the wall so that some light spilled over onto it.

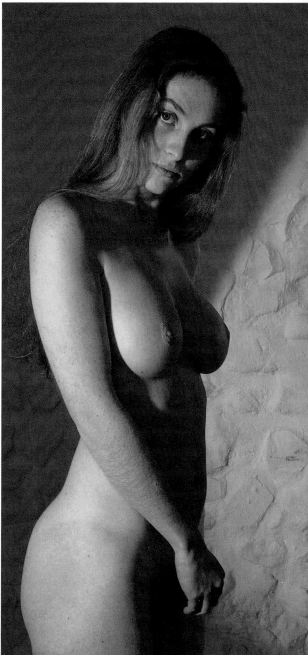

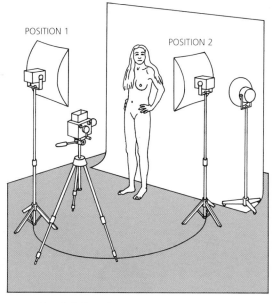

◁ △ **Soft sidelighting**

As you can see from the shot far left, frontal lighting produces well-lit but rather 'flat' results. In this version, the same lighting head with softbox was moved in an arc to the right of the camera position and slightly closer to the subject (*see diagram above*). Already, this simple change has improved form and modeling.

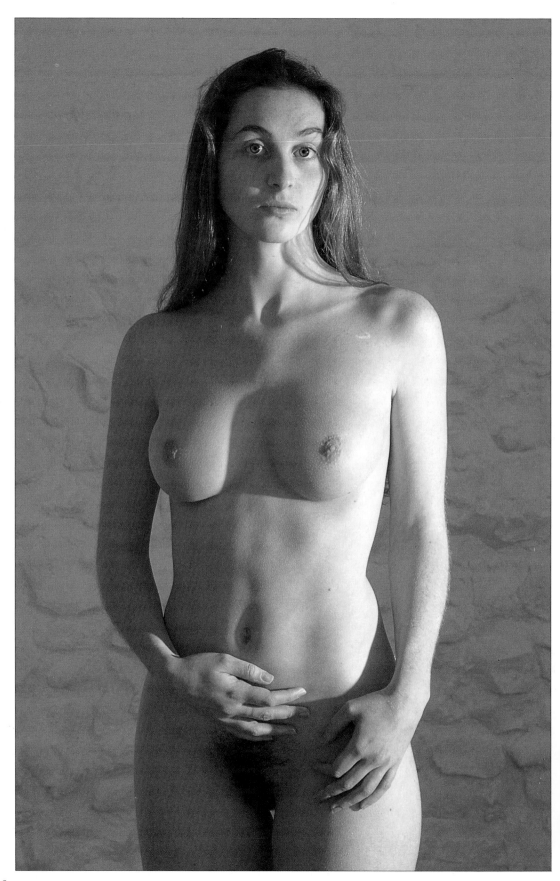

◁ Undiffused spotlight

Spotlights have an adjustable lens that allows you to focus the beam of light leaving the head. In general, they produce a slightly colder-looking lighting effect than an ordinary lighting head.

▽ ▷ Diffused spotlight

Here, the spotlight was kept in the same position as before but the model is now closer to the wall and turned to her left. To soften the illumination, a scrim was added to the spot.

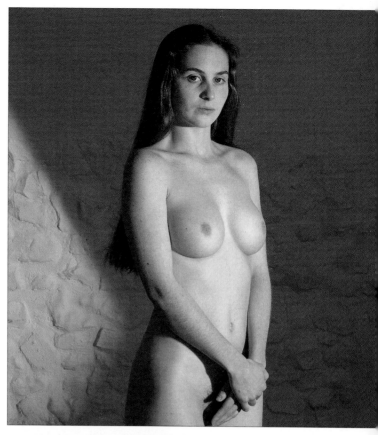

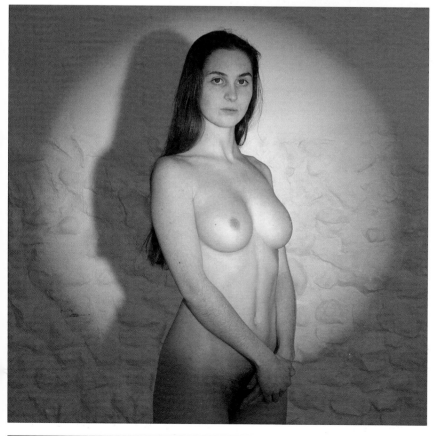

◁ Theatrical effect

The advantage of working with a spotlight is that you can adjust its lens to produce a wide range of effects – anything from a broad spread of light to a tightly focused, stage-like beam, such as the example shown in this photograph.

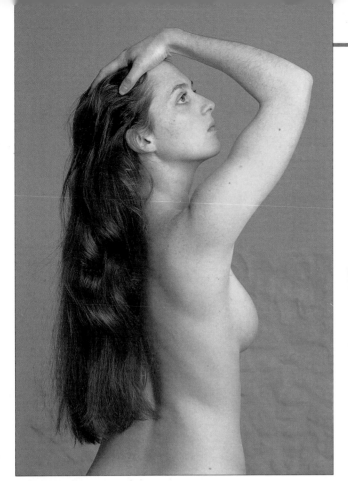

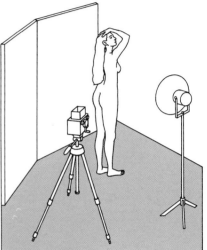

◁ ▽ One light and reflectors

The disadvantage of working with a single light is that often the contrast between the lit and unlit parts of the subject's body is too great, unless the lighting is kept frontal and flat. An easy way to overcome this problem is to use a single light at an angle to the subject and then to position reflectors to return some of the main light to fill in the shadows (*see diagram below*).

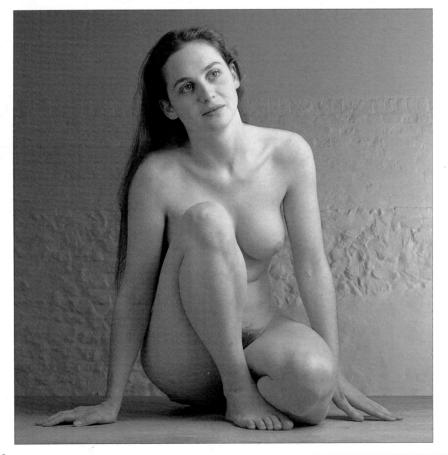

◁ Lighting height

Although not to be taken as a 'golden rule', generally lighting heads should be positioned at about the same level as the subject's eyes (or at least the main light in a multi-light set-up). With the model squatting down on the floor like this, it is important to lower the lighting stands so that she is not lit solely from above, which would create unattractive shadow areas on her face and body.

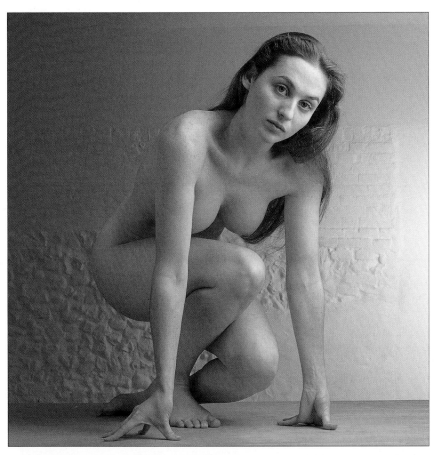

◁ **Two diffused lights**
Using two lights both fitted with softboxes gives you a lot of flexibility. With this set-up, you can reduce subject contrast while still maintaining subject form and modeling. Keep one light frontal, or semi-frontal, and use the other as a side-positioned fill-in light. When using two or more lights, always check that you are not producing conflicting shadows. A more natural effect results if all the main shadows fall in the same direction.

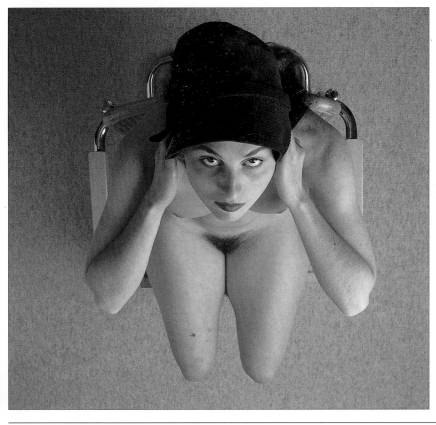

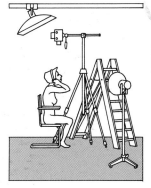

◁ △ **Overhead view**
In a purpose-built studio, overhead gantries can be used for positioning high-level lights (*see diagram above*). The gantry light is fitted with a softbox, but a light positioned at the subject's eye level was still needed to prevent ugly shadows being cast downward from her head and arms.

Simple Lighting Set-ups

You DON'T need masses of expensive or complicated equipment to set up a simple studio in a spare room. In fact, for most photographs, a two-light kit is all you really need. Then, as your technique becomes more demanding, and your budget allows, you can add any number of accessories.

To increase the range of effects you can achieve with a two-light set-up, one of the most useful accessories you can add is a set of reflectors. Purpose-made reflectors are available in a range of shapes, surface colors and finishes but, for most purposes, large pieces of white cardboard work just as well.

Other useful accessories include devices to alter the quality of the illumination produced by your main lights – such as soft-boxes, scrims, and reflective umbrellas – and others to control the spread and quality of light from each unit – such as snoots and barndoors.

To allow you to control the height of your lights, each should be mounted on a fully adjustable lighting stand.

If you intend to use artificial illumination in conjunction with daylight, then you will have to choose flash lighting. This is because flash has the same color temperature as daylight and so will not produce casts on color film. When shooting in black and white, you can use either flash or studio tungsten lights.

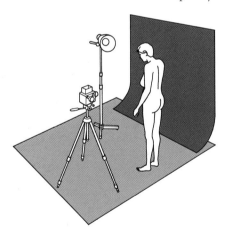

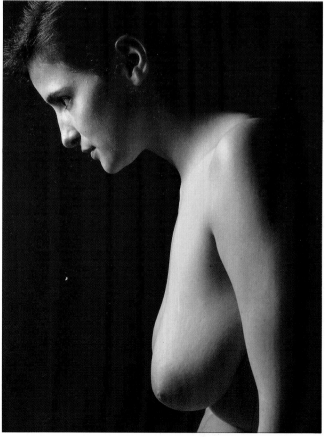

△ ▷ **Single light**
For this simply lit study of the human figure, the camera was set up on a tripod to frame the subject's profile. A single light only was used. This was placed on a lighting stand, adjusted to the height of the subject's eyes, to the left of the camera position, so that its light struck her at about three-quarters on. A large piece of black background paper, well back from the subject, was used to isolate her in a featureless space.

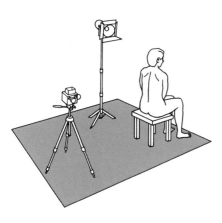

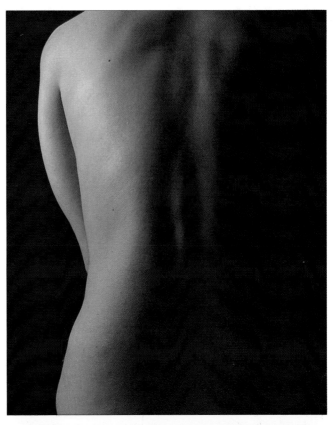

△ ▷ Single light and barndoors

This photograph was produced using one light, placed to the left and in front of the camera position, and fitted with a set of barndoors. The light was a little higher than the seated figure, so the lighting head had to be angled downward slightly. In order to help strengthen the graduation of tone from the top to the bottom of the figure's back, the adjustable flaps of the barndoors were used to restrict the amount of light reaching the lower half of the figure.

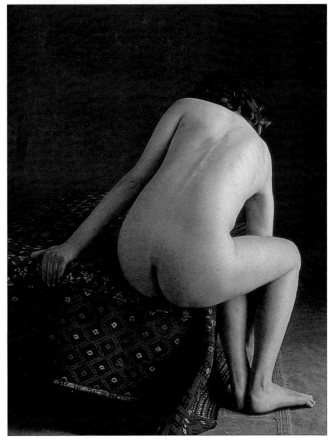

△ ▷ Two lights and softbox

The general illumination for this image was produced by a light fitted with a softbox in front of and to the left of the camera position. The brighter highlighting was created by using another light, to the right of the camera, approximately in line with the subject's profile. When using two lights like this, make sure that you don't accidentally produce conflicting sets of shadows.

Using Window Light

PHOTOGRAPHING IN daylight indoors is one of the easiest ways to start shooting the human figure. One of the first things you notice is that light levels fluctuate very considerably as you move closer or further away from the windows, and it is this variability of illumination that allows you to experiment with a whole range of lighting effects in a reasonably confined area.

As your models move around within the room, take a careful note of how the daylight falls on the different planes of their bodies. A step or two in any direction, a slight twisting of the torso, or just moving the arms up or down slightly can completely transform mood and quality.

Keep checking the scene through the camera's viewfinder, so that you can use the edges of the viewfinder frame as a cropping device to exclude all the room elements that are not to be a part of the final image. Then, when you are completely happy with the effect you can direct the models into their final positions and poses before shooting.

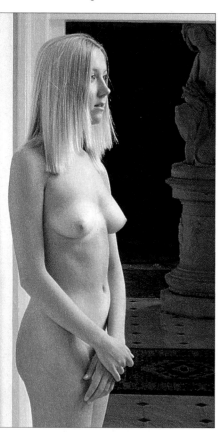

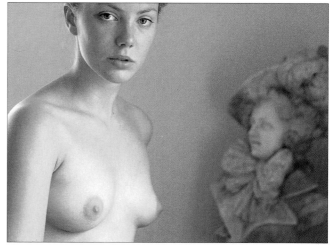

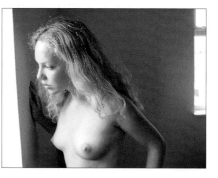

△ **Using reflectors**
In order to create this type of even lighting effect indoors using window light, you may have to position a reflector opposite the light source to direct extra illumination into the shadowy areas of the subject.

△ **Background contrast**
The model, standing face on to a large window with light-colored surfaces all around acting as reflectors, stands out effectively against the gloomy interior of the background room against which she is framed.

△ **Important highlights**
The front window gives the main illumination here, but the rear ones provide just enough light to create an important band of high-light on the back of her arm.

▷ **Bright but sunless sky**
Although there are distinctly lit and shadowy surfaces on this model's body, the window light came from a sunless sky and so contrast is not too great.

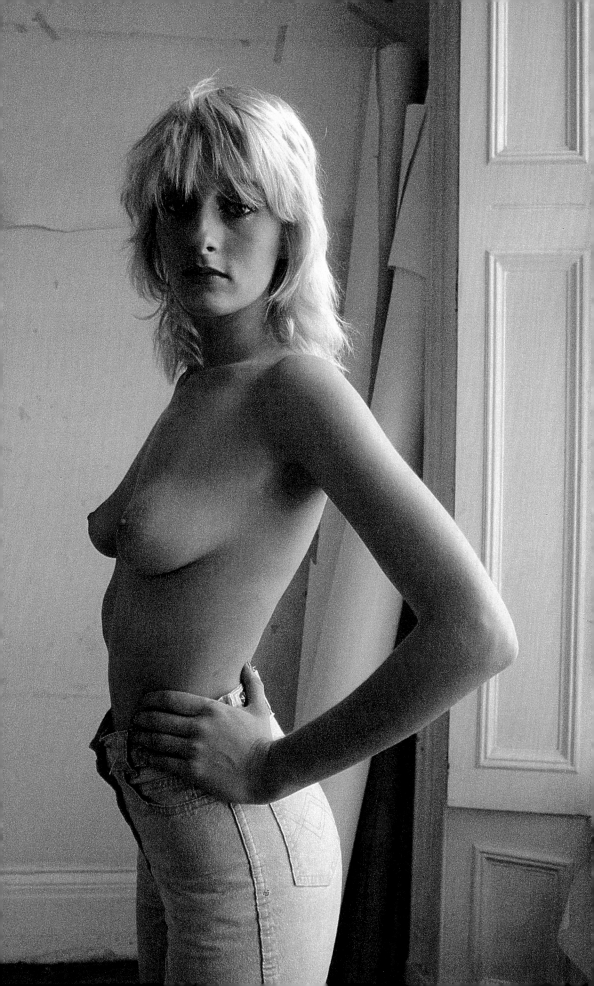

Directing the Subject

Most models will look to the photographer to give them some guidance as to what they should be doing at all stages throughout the session – sitting or standing, facing the camera squarely or more three-quarters on.

More subtly, you will also need to make sure that every aspect of the model's pose – right down to the position of the fingers, the tilt of the head, and even the flexing or relaxing of certain muscle groups to alter the appearance of the skin – is satisfactory.

If you are happy with the lighting, next use the camera's viewfinder to check how the figure merges with or stands out from the background. Work out the exposure and then direct the model in any final details of position, expression, form, and rhythm that will provide the mood and atmosphere to unite the entire image.

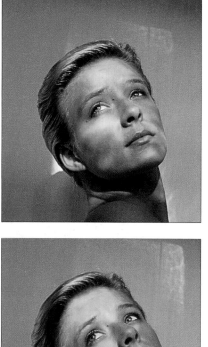

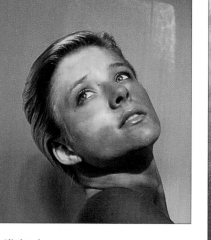

△ **Slight changes**
Often, just a slight change can make the difference between a photograph that is all right and one that is a winner. The two shots here, top and above, are nearly the same, except in the one above I had the model move her head back slightly, so that the shadows worked better on her face, and asked her to open her mouth just a little.

▽ ▷ Recomposing the shot

The only effective way to judge how the final picture will look before you have taken it is to monitor the subject through the camera's viewfinder. The straight edges of the viewfinder allow you to see the subject without being distracted by anything falling outside the picture area. With these two pictures, it was the shadows cast from the window, which is out of the image area, that dictated the change in position of the model's head. I also decided to recompose the larger shot below to prevent the shadows from becoming too dominant.

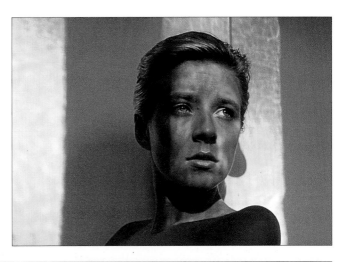

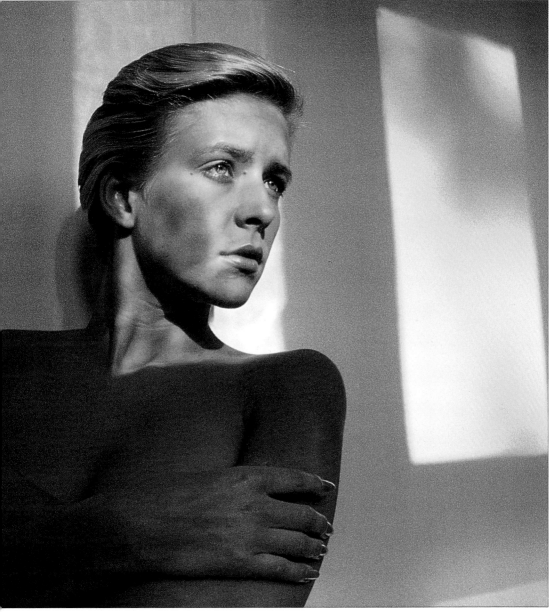

Framing the Subject

ONE WAY OF dividing up the space within which you pose your subjects is to look for naturally occurring frames within the scene. In this way, you signal the principal subject of the shot to the viewer, and you also have an anchor point around which to build your composition.

As well as frames in the external environment, such as doorways, windows, archways, or even the sides and back of a chair, look for less obvious types of frame. These could include an arrangement of colors, tones, or shapes that become apparent only when seen from a particular camera angle.

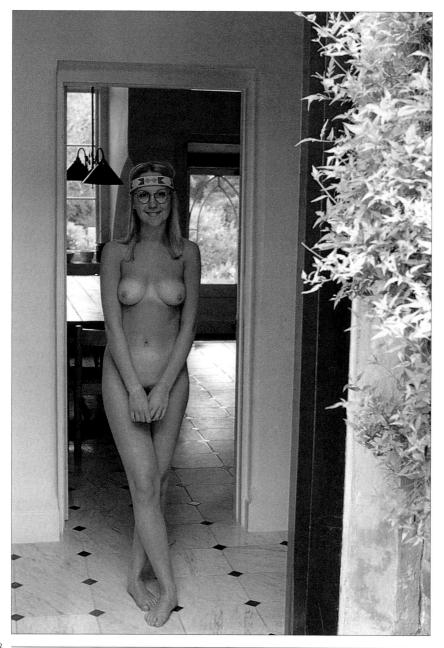

◁ **Frames that conflict**
With the camera pulled back from the subject, the use of frames in this shot is both striking and bold. However, the brightly sunlit foliage on the right of the picture tends to attract attention and the figure inside the doorway looks slightly under-exposed. Frames usually register most strongly in the foreground, so providing the picture with depth and distance.

▷ **Frames that enhance**
In this version of the image, the camera lens has been zoomed to a telephoto setting. This has simplified the framing, and made the figure much larger in the picture. With the sunlit foliage removed, the exposure for the subject is now fine.

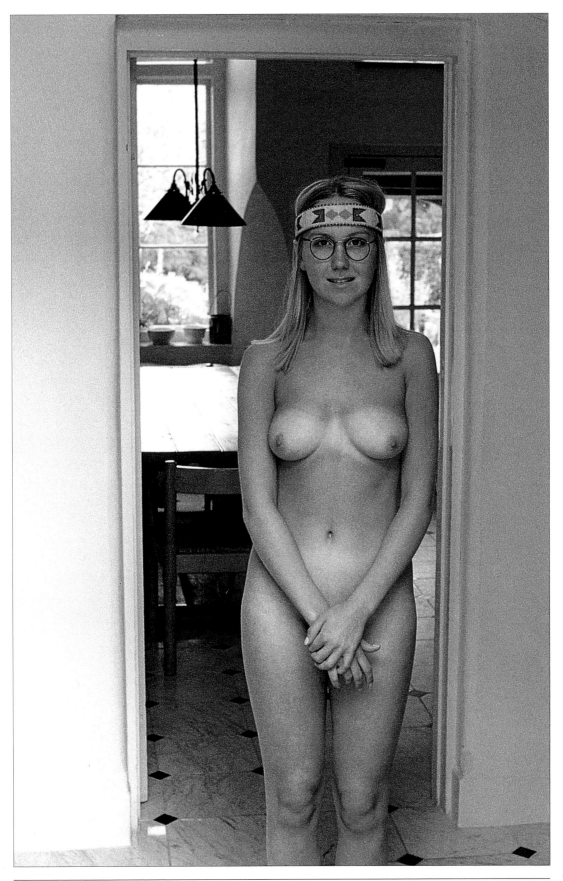

Working Around the Subject

IN ORDER TO maximize the number of successful pictures from a photographic session, don't be satisfied with taking just one or two shots of each set-up. More studio time is spent on adjusting lights and getting the exposure right than on taking pictures, so the little extra time it takes to shoot a few additional frames could pay big dividends.

As you are taking each frame, tell your subjects how they should be moving and the expressions you want. Try to build a rhythm so that as they move within the area you have already defined for them, you can take a series of shots from all angles without shifting the camera position or resetting the lights. And bear in mind that even slight changes in position can make major differences to the final result.

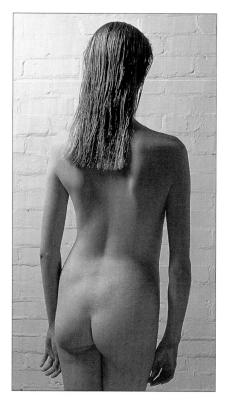

◁ **First static pose**
This is the first shot in the sequence of pictures on these pages, which were all taken in less than 30 seconds. Here the model is standing relaxed and static, but at this point I am already explaining to her how she should start to move and preparing for the next shot.

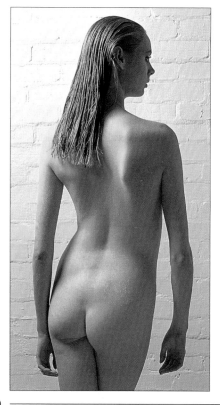

◁ **Starting to move**
Having already explained to the model how I wanted her to start moving, I was ready to take this shot as she turned her head to the right and began to swivel her body.

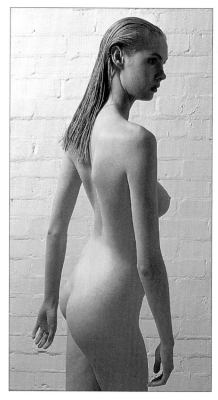

▷ **Following through the movement**
Here the model is starting to pivot toward the camera. There is now much more movement evident in this shot.

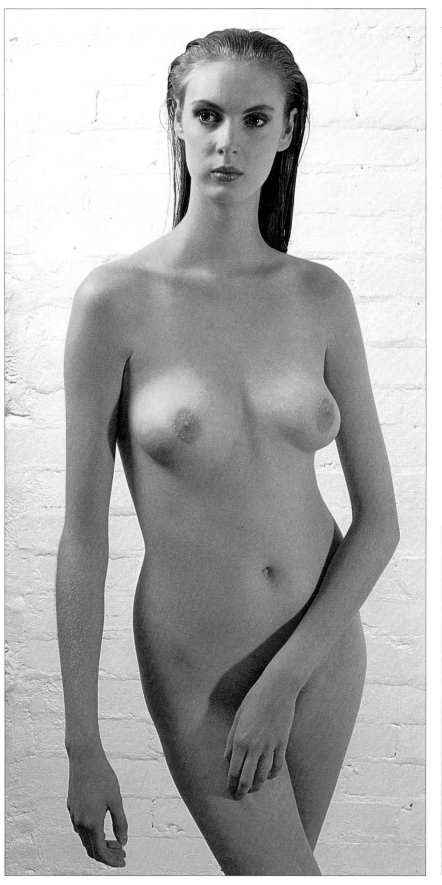

◁ **Final position**
This sequence of
pictures comes to
an end as the model
completes her turn,
finishing up facing the
camera. Depending on
how you intend to use
the pictures – in a
magazine or on a
book jacket, for
example – even the
final position of the
arms and the direction
of the gaze may be
important factors.

HINTS AND TIPS
■ When subjects
are moving and you
want to take pic-
tures quickly, use a
camera with an
autowind or motor-
drive facility to
advance the film
after each frame.

■ To take a series
of shots of moving
subjects, use a
lighting arrange-
ment that produces
a broad spread of
illumination.

■ To lessen changes
of camera position
during a sequence,
tell the subjects in
advance the area
they can move in.

Lighting Intensity and Form

WHEN PHOTOGRAPHING the human body, form is a vitally important picture element. The appearance of form in a photograph communicates to the viewer some impression of the roundness and softness, or the hardness and substance – the three-dimensional reality – of the figure in front of the camera lens.

Frontal light flattens form while oblique light intensifies it. Flood all of the subject with the same intensity of light, so that no part of the body is seen in shadow, and you will largely destroy the appearance of form. Likewise, if you underlight the subject, so that there are no areas of highlight, form will again be largely suppressed.

Form is most apparent when there is a gradation of tone across the subject, This is best achieved when the illumination strikes the subject from an angle or directly from one side or the other, rather than straight on. This type of lighting will more brightly illuminate those part of the subject closest to the source, and the gradually fall off in intensity as it travels further. As you can see from the photographs below and opposite, it is where the lighting changes from bright to less bright that you gain the best impression of subject form.

If you are using a two-light set-up, make sure that the output from each unit is different, or that one light is positioned much further back than the other. This ensures that there is a distinct difference in the amount of illumination reaching the subject from each light. Without this, subject lighting may be too even.

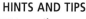

HINTS AND TIPS

■ Very uniform lighting will often suppress the appearance of form in the subject.

■ Angled lighting is preferable to completely frontal lighting when emphasizing form.

■ Small changes in orientation of the subject to the light source can create a huge impact on the appearance of form.

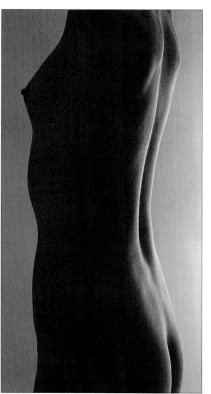

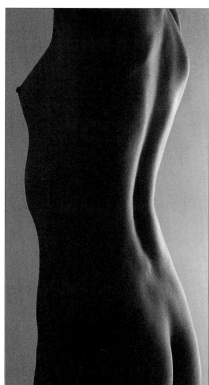

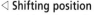

◁ **Shifting position**
For both of these photographs the lighting was identical – the only difference is that the subject shifted her position slightly in between frames. Note, however, that in the second shot (near left) there is a more distinct impression of form running down the length of the girl's spine and around the small of her back and buttocks. This was achieved by the contrast between the highlight and shadowy areas.

▽ ▷ Daylight and reflector

Although intentionally low key, the lighting here was initially too uniform and flat. In order to introduce the subdued highlights, and so describe the subject's form, a circular reflector covered with slightly crinkled kitchen foil was placed to the right of the camera, and angled to reflect window light back onto the subject.

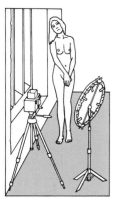

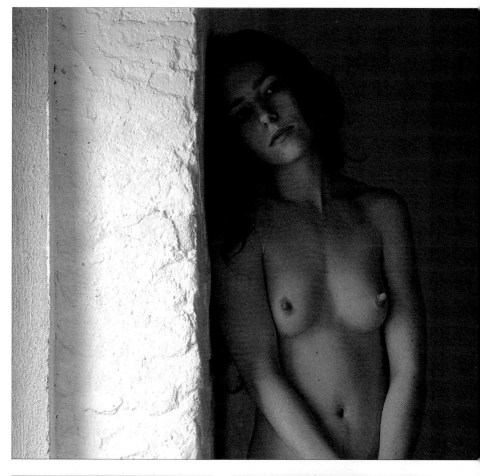

▷ New orientation

In this image from the sequence (*near right*), the model has changed her orientation to the lights, creating new areas of highlight and shadow. Where her body is evenly lit or evenly dark, there is very little indication of form.

▷ Muscle tension

Here there is a change in the model's pose (*far right*). Her right leg pushing backward has totally altered the muscle tension in her body. The best indicators of form are now the bands of light and shade merging around her buttocks and thighs.

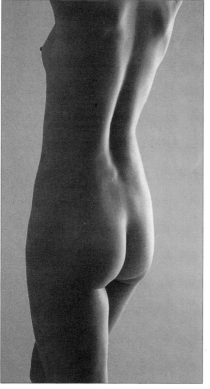

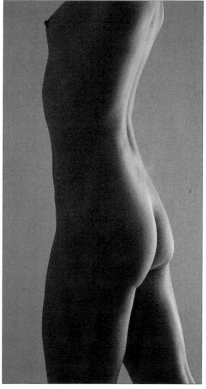

Emphasizing Height

USING A COMBINATION of the appropriate focal length lens and camera position, it is possible to distort totally the apparent proportions of your subjects, making them appear impossibly tall and leggy, as you can see in the photographs on these pages.

The usual advice that is given when using wide-angle lenses to photograph tall objects is to keep the back the camera (and hence the film inside the camera) parallel with the subject. If you tilt the camera upward to include the top of the subject, wide-angles produce an optical effect known as 'converging verticals', in which parallel lines seem to converge as they receded from the camera. This makes subjects look not only as they if they are tapering to point but also, more disconcertingly, as if they are toppling backward.

The more extreme the wide-angle's focal length, the more obvious these distortions become. But rather than considering them a problem, you can emphasize them to good effect. The lens used for the pictures here was a 24mm on a 35mm camera. In order to exaggerate the height of the subject, it was necessary to shoot from very low down (lying flat on the floor) with the camera close to the subject pointing upward.

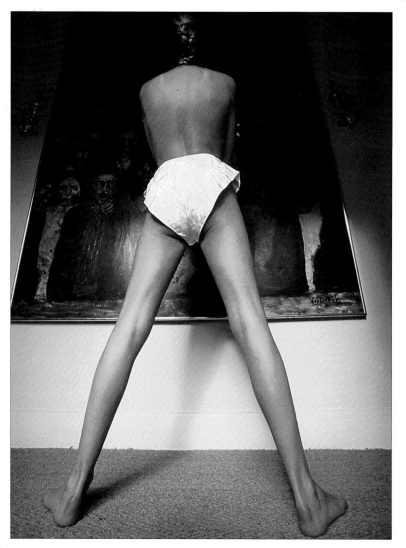

◁ ▷ **Wide-angle distortion**
In these two photographs, the appearance of converging verticals has been emphasized by moving in close and low down to the subject and pointing a 24mm wide-angle lens sharply upward. To emphasize even further the subject's apparent height, the girl's head has been carefully aligned with an area of shadow, making it look as if her head is lost in the clouds. In computer-manipulated imagery (*see pp. 136–147*), for example, this type of composition could be the inspiration for all manner of fantasy pictures.

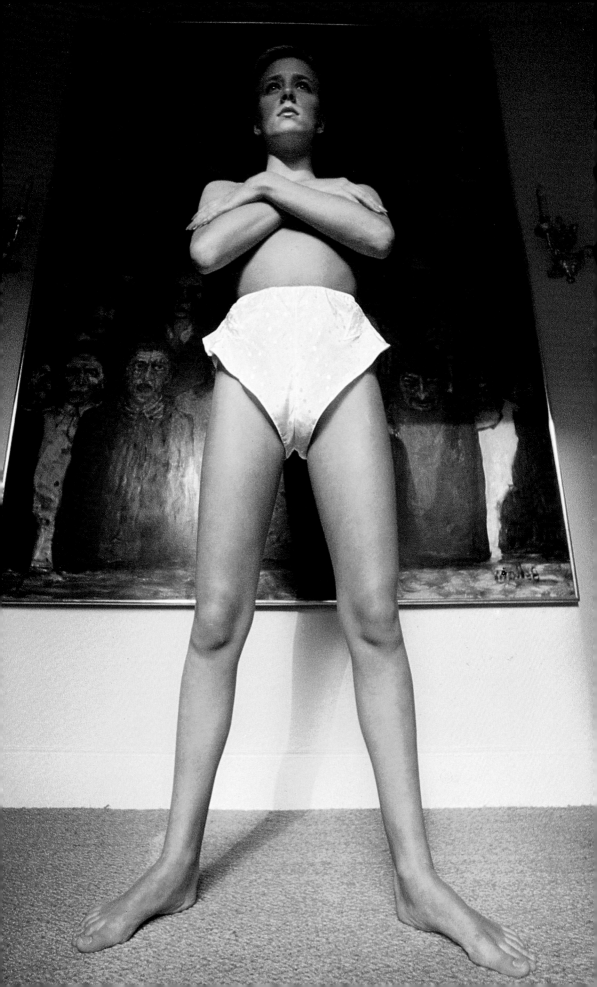

Silhouette Lighting

IN ORDER TO produce a silhouetted image, you need to position your subject between the light source and the camera, making sure that as little light as possible falls on the side of the subject facing the lens. Next, take a light reading directly from the light source, set the aperture and shutter speed accordingly, compose the shot, and then take the picture.

Most people, however, take silhouetted photographs by accident because they failed to notice that the sun, or other light source, was behind the subject at the time, with its light shining directly into the camera's lens. When this happens, the camera's exposure meter registers a generally high level of illumination and sets a shutter speed/lens aperture combination in response that causes the subject to underexpose.

Photographers using silhouette lighting on purpose usually do so to produce a very graphic image. With all surface features removed – or at least minimized – subject shape becomes the dominant pictorial feature.

▷ **Semi-silhouette**
To produce this semi-silhouette, the general studio illumination was subdued, and a light reading was taken from the highlight side of the model – the side away from the camera. In order to retain some detail in the model's skin, an exposure of 1 f-stop more than the highlight reading was set – f5.6 instead of f8 at ⅟₆₀ second.

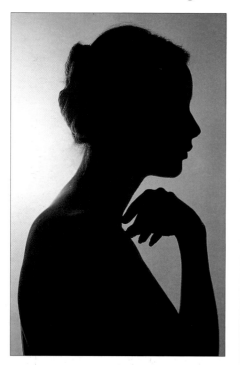

△ **Full silhouette**
The studio was in near darkness, except for the bright light behind the model. An exposure reading was taken directly from the light and this was used to take the picture, massively underexposing the subject.

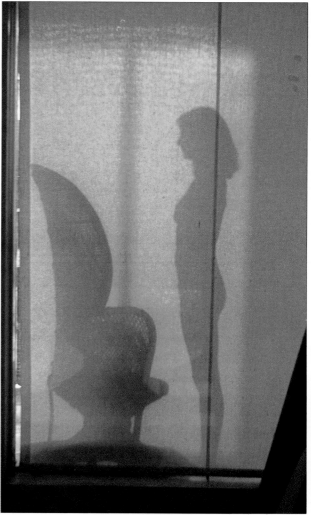

▷ **Translucent material**
To create this type of silhouette, translucent material was stretched in front of the subject. The light coming from behind then projects a shadow on to the material that you can photograph normally.

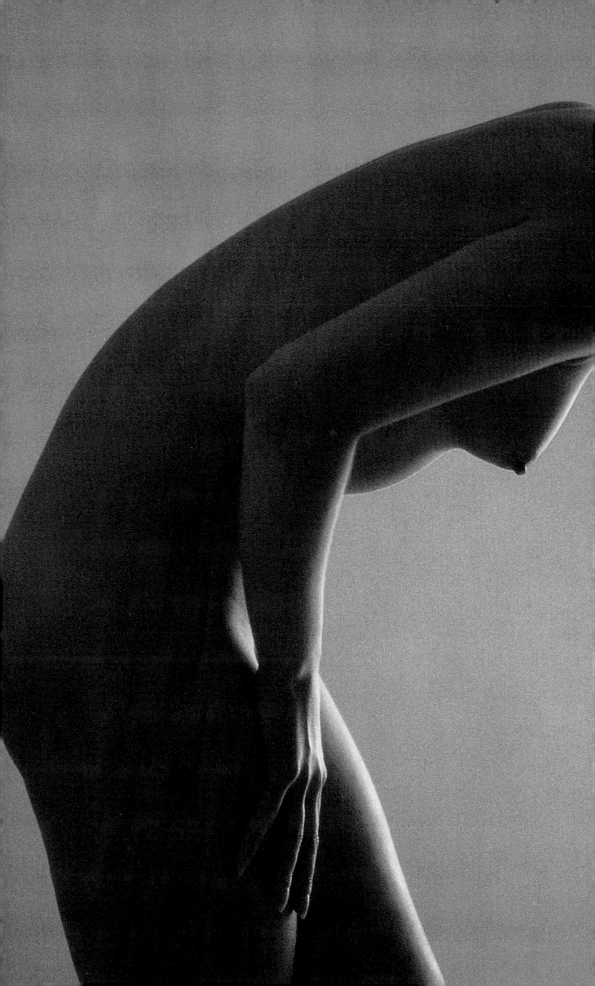

Dealing with Backgrounds

I T IS ALL too easy not to notice the effect that a background can exert on the overall mood and atmosphere of a photograph. A too sharply focused background element, for example, or even a too well defined area of color could compete with anything positioned in front of it.

To overcome this type of problem, in a home or professional studio, use a combination of camera angle, depth of field, and lighting to help subdue the background. Another approach is to remove the existing background completely by stretching large white, black, or colored lengths of heavyweight paper, painted flats, or canvas behind the subject.

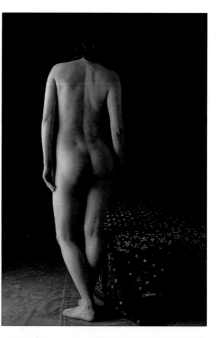

◁ **Localized lighting**
In a small room full of detail that would detract from the figure, use contrasty, localized lighting to isolate the subject by underexposing the surroundings.

▷ **Plain background**
In a study such as this, nothing else in the frame should compete for your attention. A length of tarpaulin hides the rest of the studio and provides a plain color contrast for the subject.

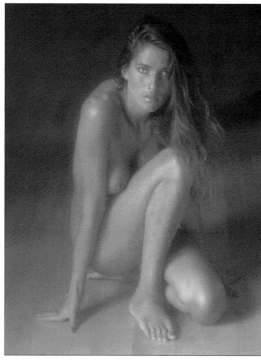

△ **Camera angle**
By adopting a high camera angle for this shot, with the lens pointing down, the subject was framed against a plain floor – an ideal technique when you cannot mask off the rest of the room.

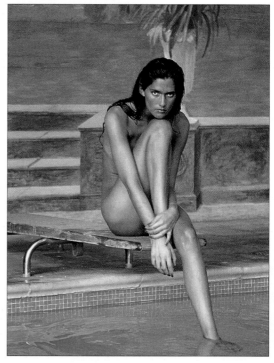

△ **Painted background**
The painted background to this indoor pool was important for the mood and extra information it imparted. However, a long lens and wide aperture ensured it was slightly less sharp than the subject.

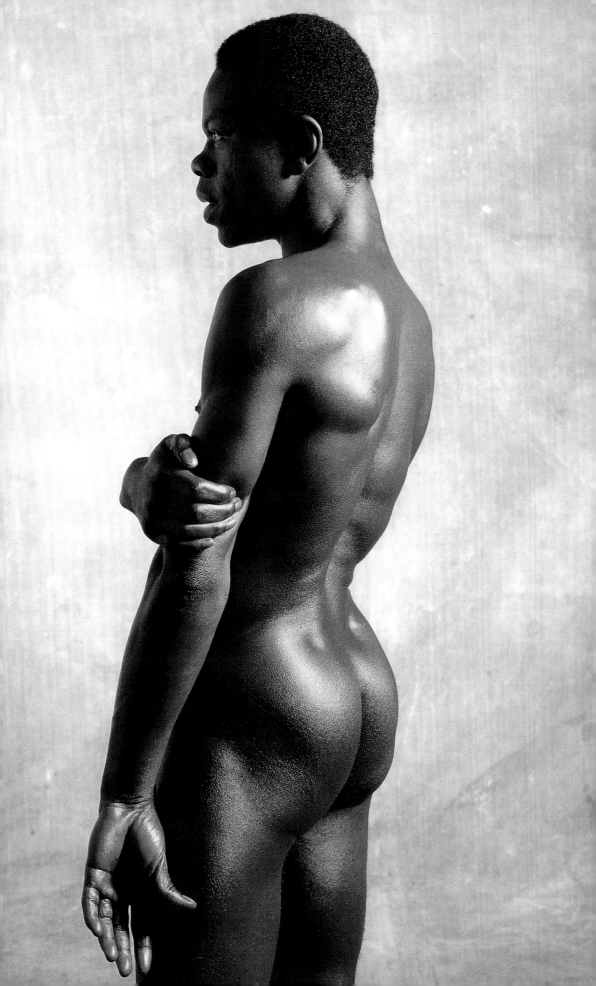

The Allure of Black and White

ONE OF THE principal and enduring attractions of black and white photography is that it makes no attempt to portray the reality of the subjects it records. We see the world around us in color, so once that element has been subtracted from the scene, a process of abstraction is immediately set in train, one that leaves photographers with a freer hand than they might have in color to apply an interpretative approach to their subject matter.

The passionate adherence that many photographers have to the black and white medium is at least in part explained by the fact that it forces practitioners to bring to the forefront certain subject attributes that they might otherwise have assigned to more subsidiary roles in their compositions. For example, form, shape, pattern, and texture may all assume far more importance, as can the arrangement of these elements within the picture area. But whether the image is tonally simplified and graphically stark or has a rich and expressive range of tonal values, black and white imagery is capable of evoking a powerful emotional response.

Another alluring aspect of black and white is that it lends itself to a wide range of darkroom techniques. Tones that are too dark, for example, can be made lighter and brighter, while those that are too bright can be darkened and subdued. Black and white negatives can also be printed on a range of different paper grades to manipulate the tonal range that will make up the final print (see pp. 132–3).

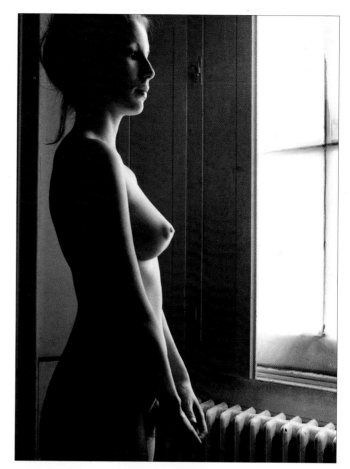

△ **Diffused daylight**
Softly gradated tones produce an image rich in detail and interest. The gentle lighting used to illuminate the scene comes from the window, which has been covered with heavyweight tracing paper to give a diffused effect.

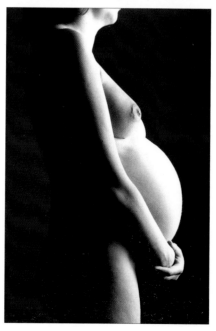

◁ **Studio lighting**
Undiffused studio flash, used to highlight the subject's heavily pregnant profile while keeping the background in shadow, suppresses form in favor of shape.

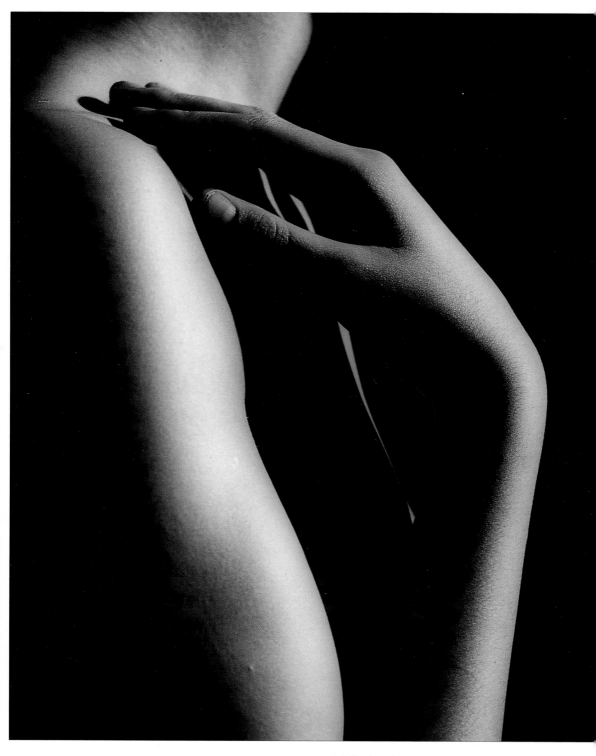

△ **Selective view**
Using a telephoto lens to frame a very selective
view of the subject was the first step in produc-
ing this highly interpretative image. Subject
abstraction was then taken further by employing
very contrasty lighting to produce distinct blocks
of highlight detail alternating with impenetrable
areas of shadow.

HINTS AND TIPS

■ When shooting subjects on black and white film, make sure it is not subject color or color composition that largely attracted your attention to the scene.

■ Shape, tone, texture, and pattern may become more important as subject elements in black and white than they are in color.

■ You can more clearly differentiate some tones in black and white by using colored lens filters to manipulate film response to different subject colors.

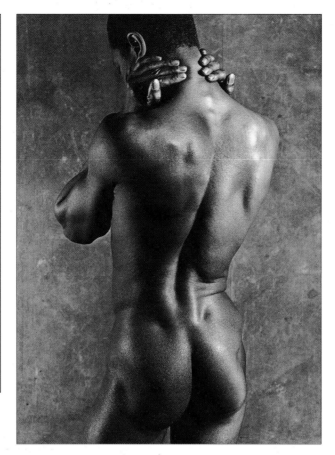

◁ **Tangible results**
This well-lit subject – in which the brightest highlights and the deepest shadows are all well within the film's recording range – has been combined with a soft grade of printing paper. The image produced has such presence that you feel as if you could reach out and almost feel the texture of the subject's skin.

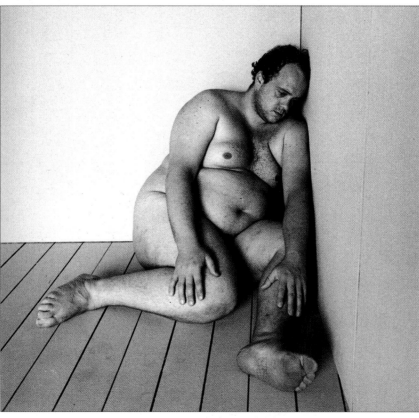

◁ **Crestfallen figure**
The absence of color in this photograph helps to reinforce the bizarre nature of the subject matter.

▷ **Toned result**
Black and white prints can be made more colorful by toning them in any of the many proprietary solutions that are readily available. Either the whole print can be toned or, as here, just selected areas.

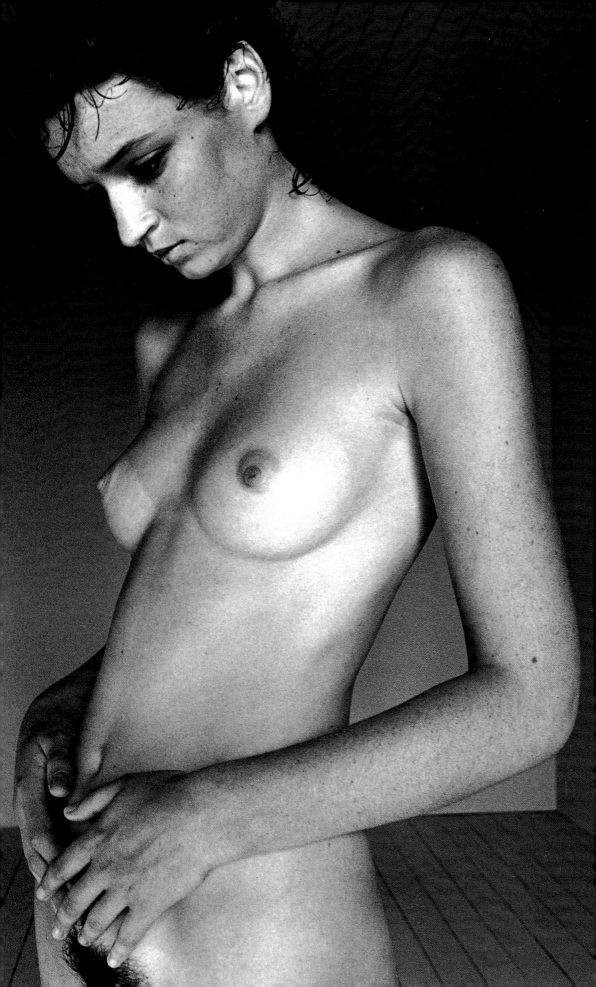

Changing the Emphasis

B Y FRAMING your shot so that the model's face is cropped out of the image area, you instantly bring about a radical change in the emphasis of the resulting photograph.

We recognize other people primarily by their facial features, and our facial appearance is closely tied into our own sense of identity. So, once that point of reference is removed from the picture, the naked body that remains becomes a depersonalized study of shape and form, texture and pattern, or color and tone. Rather than the picture being that of a recognizable person, the shape of the breasts, the swelling of the abdomen, the play of light and shade, the texture of the skin, and the patterns created by the fingers take on more importance.

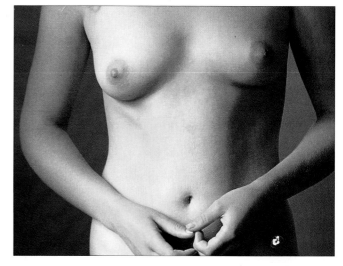

△ **Suitable picture shape**
The horizontal, or landscape, framing of this shot helps to emphasize the angular shapes formed by the model's arms, anchored at the bottom of the frame by her intertwined fingers.

▽ **Hands that communicate**
In these two images, the model's hands are very expressive, communicating the degree of awkwardness, verging almost on shyness, that she seems to be feeling about her nudity.

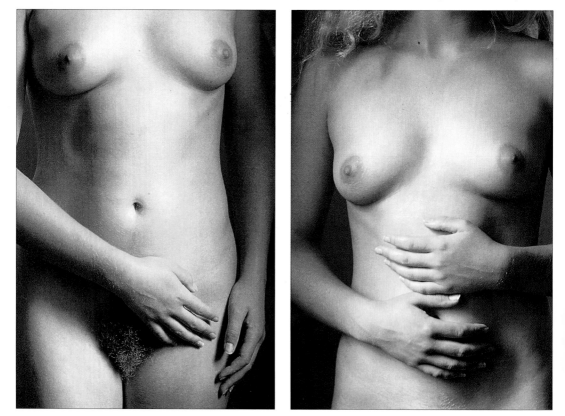

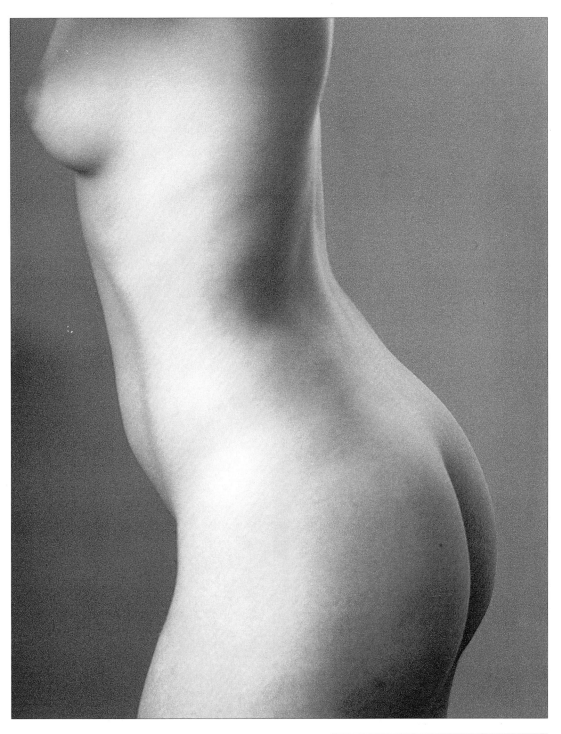

△ Emphasizing shape and texture

This photograph is dominated by repeating shape and a lighting scheme designed to emphasize the creamy smoothness of the model's skin. The soft roundness of the model's breast finds echoes in the shape of her shoulder, sweeping the eye down to the gentle swell of her abdomen and then the perfectly repeating shapes of her buttocks.

HINTS AND TIPS

■ Using a telephoto zoom lens gives you the option of emphasizing specific parts of your subject's body without having to shift camera position or change lenses.

■ Inexperienced models might feel more relaxed knowing that their identity will not be obvious in the resulting photographs.

Lighting Mood and Atmosphere

GOOD PHOTOGRAPHY is more than simply producing a recognizable likeness of your subject. Modern advances in lens design and the near-universal inclusion of autofocus, autoexposure, and automatic film advance in all the popular camera formats have made this part of the process easier than ever before.

What sets some pictures apart from all the rest is often the quality of the light that the photographer has used to record the subject, rather the appearance of the subject itself. The word 'photography' actually means 'drawing with light', and it is light that is the chief tool the photographer uses to conjure up a particular mood and atmosphere

that will be communicated to the picture's audience.

There are no unbreakable lighting rules you can apply to any particular subject. There are, however, a few guidelines that generally hold true. Bright, full lighting, known as high-key (see pp. 52–3), often produces an open, spacious, and airy type of atmosphere, while subdued lighting, or low-key (see pp. 50–1), produces more of an enclosed mood, which can sometimes feel oppressive. Try to avoid lighting schemes that are very even in appearance – either all bright or all dark. Even if the color or tonal differences are only slight, it is the contrast between them that helps to bring your pictures to life.

▽ ▷ **Varying the mood**
Although both of these photographs use a similar setting and props, their moods could not be more different. This ability to alter at will the illumination in order to conjure a variety of moods and atmospheres is one of the chief advantages of working indoors with artificial lighting.

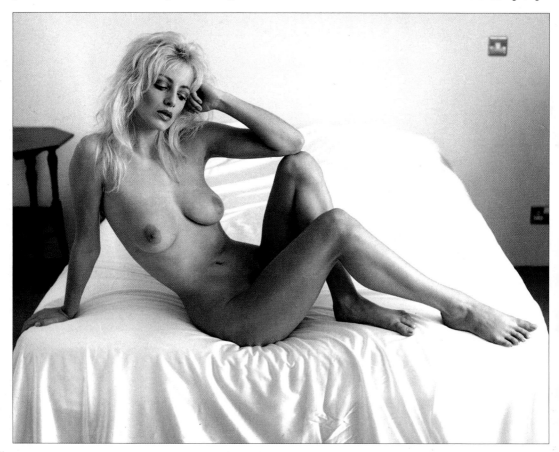

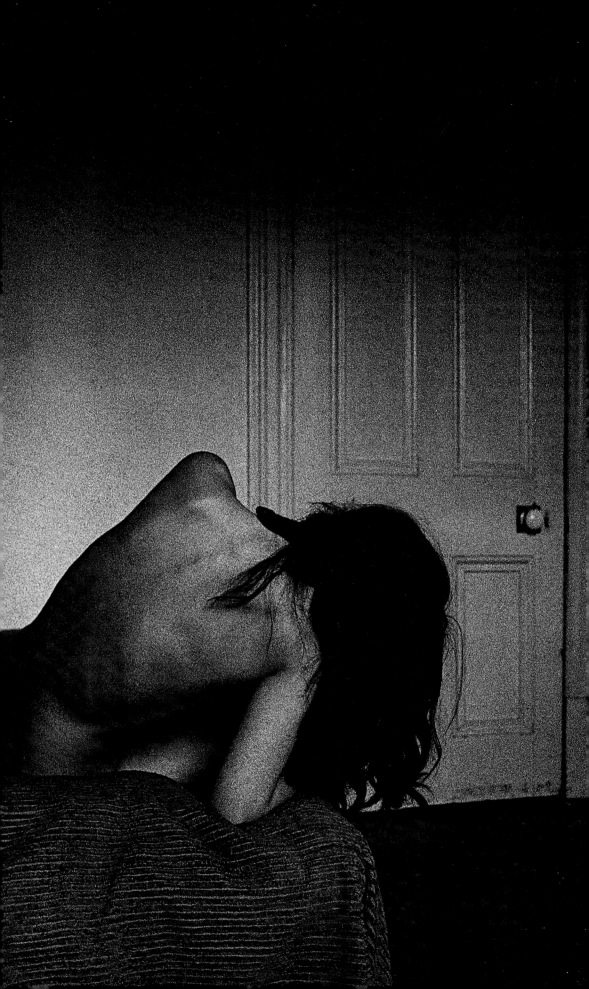

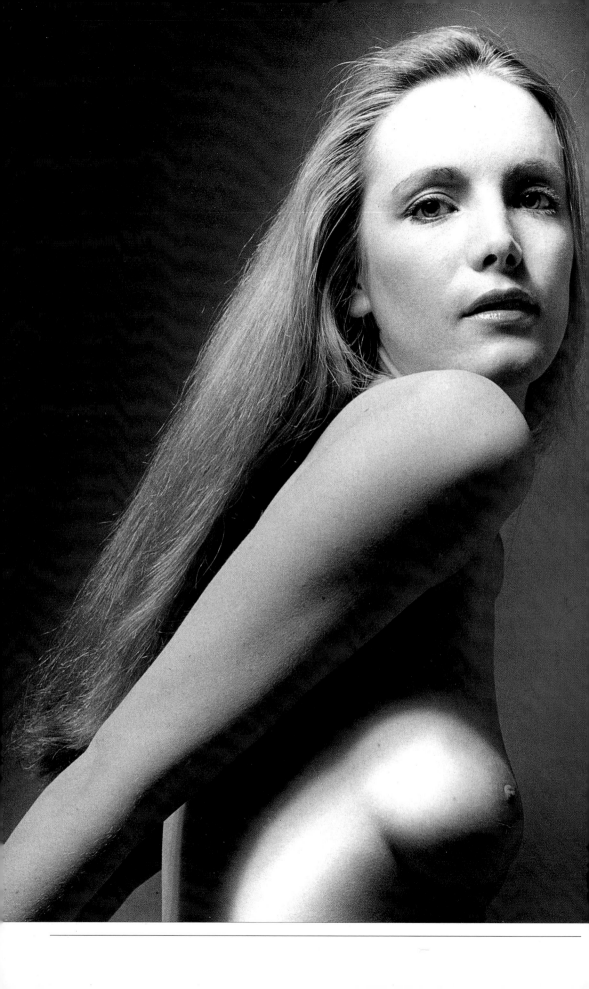

◁ **Hollywood lighting**
This style of lighting is reminiscent of the hey-day of the Hollywood stills photographers. The lighting is full, to produce a richly detailed image, while there is still sufficient contrast between the highlights and shadows to give depth and substance to the subject.

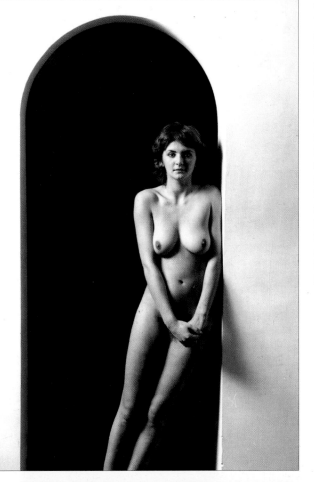

◁ **Sunshine mood**
The style of the arched doorway against which the model poses, coupled with a lighting set-up producing enough illumination to bleach the texture out of the surrounding wall, brings to mind a Mediterranean type of setting. A small lens aperture (f16) and a fast shutter speed (1/250 second) ensured that the interior of the room was record-ed on the film as a featureless area of impenetrable shadow.

▽ **Restricted tonal range**
The restricted tonal range of this low-key image brings to mind a mood of intimacy, which is very much in keeping with the seductive pose of the full-figured model.

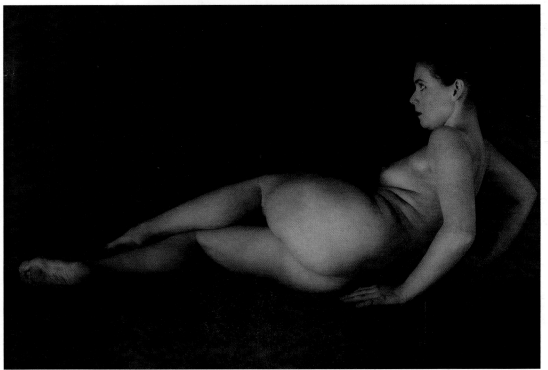

Low-key Lighting

ONE OF the key determiners of a picture's mood and atmosphere is its lighting intensity. Photographs that are essentially low lit, and where dark tones (or colors) and shadows predominate, are said to be low-key in lighting style.

Low-key photographs often produce an enclosed feeling, as if there is something secretive and furtive, something that is best not revealed by the light. Use low-key lighting to help create a sense of mystery or to add a touch of drama to your work.

To create this type of image, you can underexpose a scene that is already underlit, or take your light reading exclusively from the brightest highlight available, and allow everything else to darken.

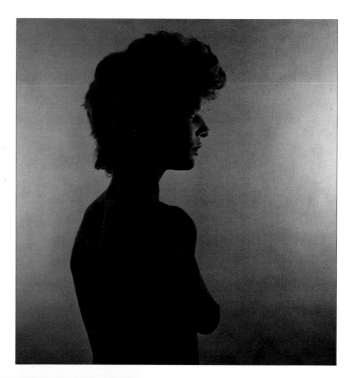

△ Near silhouette
The lighting used here, apart from the spotlight pointing directly at the model's face, has reduced the subject to a near silhouette. The generally subdued lighting has thrown the two areas of background highlight into sharp relief.

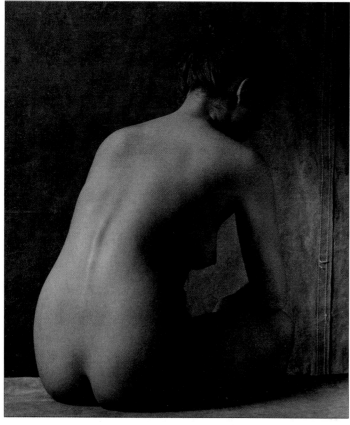

◁ Suitable pose
The subdued quality of this low-key lighting is reinforced by the quietly pensive pose of the subject. With her back to the camera, it seems as if she has been recorded in a very private moment.

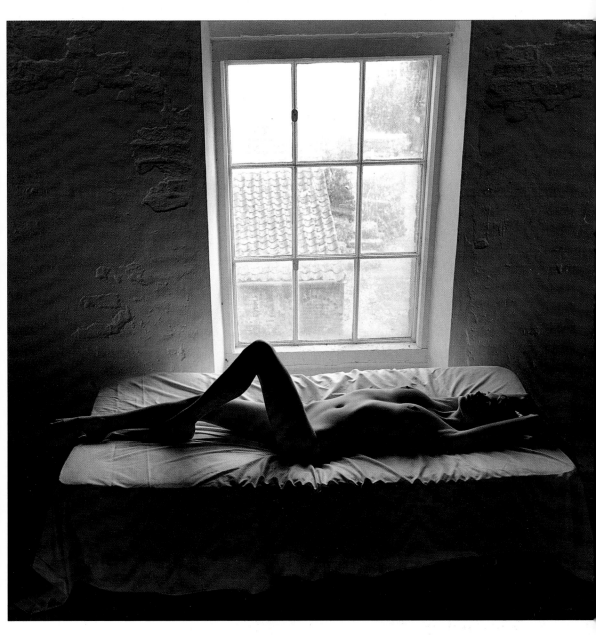

△ Window lighting only
The only light used to illuminate the subject came from the window behind the bed. The exposure reading was taken from the window highlight, ensuring that the scene outside was 'correctly' exposed while most of the interior was dark and low key in comparison.

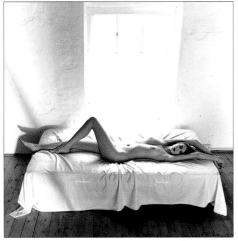

◁ Window light and flash
This picture is the same as the one above except that the window light has been supplemented with studio flash. This brightly lit equivalent strikingly illustrates the difference in lighting atmosphere between high- and low-key techniques (see also pp. 52–3).

High-key Lighting

HIGH-KEY pictures are very different in mood and character to low-key images (*see pp. 50–1*). These brightly illuminated pictures, in which light tones and colors are the predominant feature, conjure an atmosphere of candor and openness. Even when subjects are tightly cropped, there remains a feeling of airy spaciousness.

The best way to approach high-key pictures is to take a local exposure reading from the darker tones to be included in the shot. The exposure meter will then recommend (or set) a wider aperture and/or a slower shutter speed. If, however, there are very bright highlights in the scene, these may be overexposed, and so you will need to reduce exposure.

△ **Color touches**
In a face that seems to be bleached of color by a combination of very bright lighting and slight 'over-exposure', the subject's red lips and green eyes become riveting features.

◁ **Unusual viewpoint**
The intriguing nature of this camera angle, looking up the model's body toward her breasts, has been strengthened by the high-key lighting that has resulted in near shadowless skin tones.

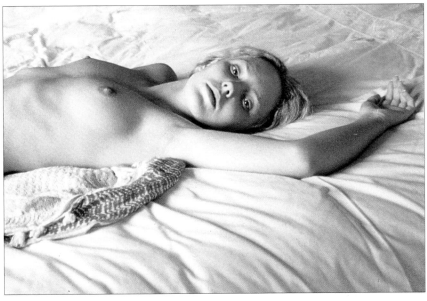

△ High-key abstraction

This abstract image is the result of showing only a selective part of the model's body and then massively overexposing the frame to produce a smooth, featureless skin tone.

◁ Reflective surroundings

Here, I took advantage of the reflective color of the bed cover to create an essentially high-key image.

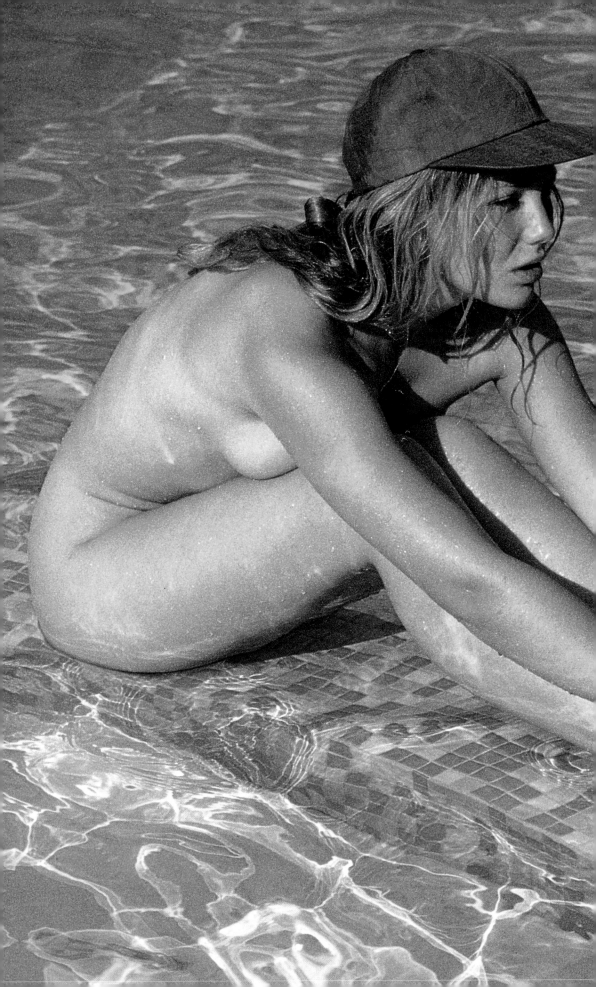

Location Shooting

APART FROM THE enormous diversity of settings in which to pose your subject, it is the never-ending changeability of natural light that makes location shooting so appealing to many photographers. From dawn's first light to the last rays of dusk, sunlight produces an almost infinite palette of colors, tones, contrasts, and textures to enliven any scene or subject setting. Of course, there will be times when the weather acts against you and shooting is impossible, and you will also need to find a location to work in that is quiet and private.

Using the Setting

THE SETTING IN which you see the human figure can be vitally important to the success of a photograph. You don't always want to see pictures of the human form in isolation, so a suitable setting can not only form a part of a more interesting composition, it may also inspire a specific photographic approach by providing the subject with something to interact with.

As well as providing additional visual elements, the setting also often influences lighting quality. Stark white walls, for example, combined with bright sunlight can bathe a courtyard setting in intense light; sunlight filtering through a dense canopy of foliage will be softened and colored; while a more open canopy may produce a dappled effect, as highlights alternate with shadows. Take the time to explore the potential offered by even the most seemingly prosaic of settings.

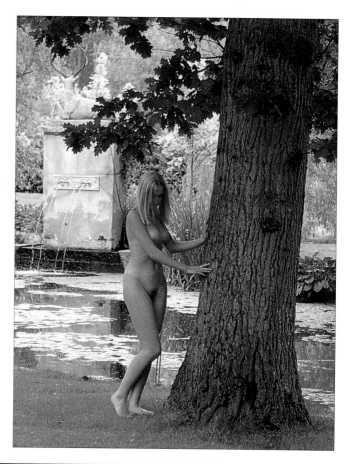

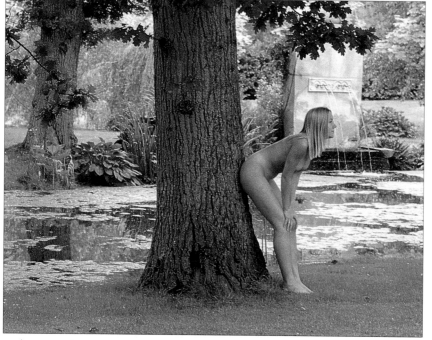

△ ◁ **Natural prop**
This pondside setting made an attractive backdrop for the model to pose in front of. However, by including the tree in the shot, with the fountain on the far bank, it was much easier to divide up the picture area. The model also found that she felt less awkward when using the tree as a natural prop, and this comes through in the photographs.

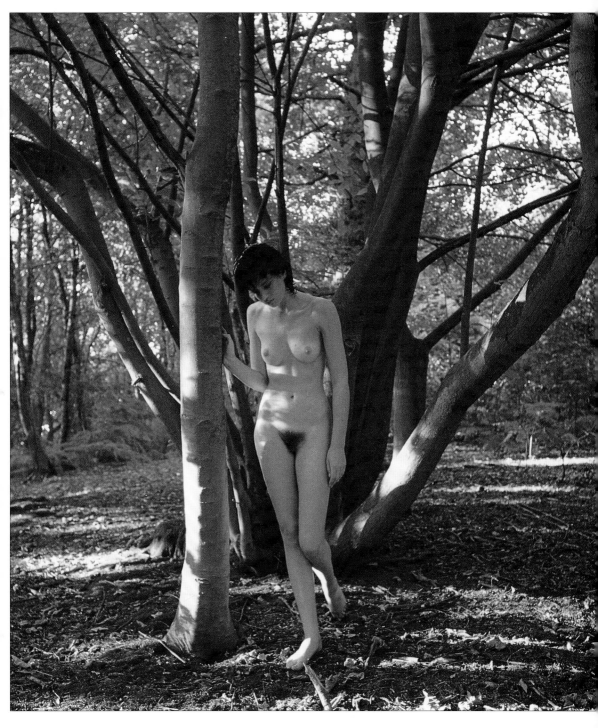

△ **Tree canopy**
A thin tree canopy has allowed ample light to filter through to bathe the model in dappled light in this woodland setting. Positioned behind a slender tree trunk, most of her body is in soft shadow, but there are sufficient highlights, both on her body and on the leaf-littered forest floor, to give the scene depth and substance. The bands of light and shade also create pattern and help to accentuate texture and form.

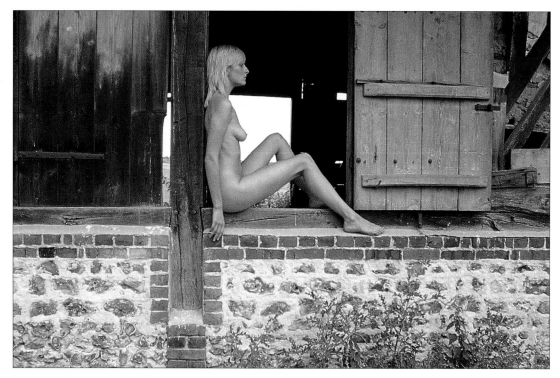

△ Multilayered image

The area bounded by the timber supporting beam and the open door made an ideal frame in which to position the model. The deeply shadowed interior of the building, contrasting with the brightly lit sky beyond, gives the picture a multilayered quality that helps to emphasize the three-dimensional nature of the scene.

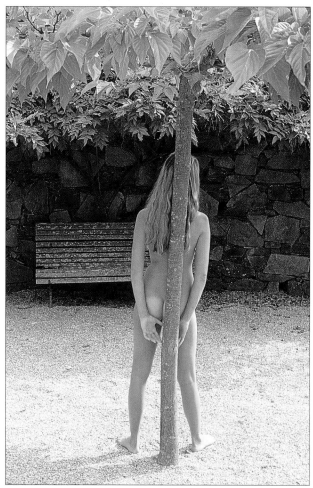

◁ ▷ Courtyard setting

If you include too many visual elements in a photograph, you run the risk of distracting the viewer's attention from the principal subject. Before taking these pictures, I first removed about 15 large pots of flowers and raked the gravel smooth and clean. It is the starkness of the courtyard setting, with its single tree and garden bench, that produces the attention-grabbing impact.

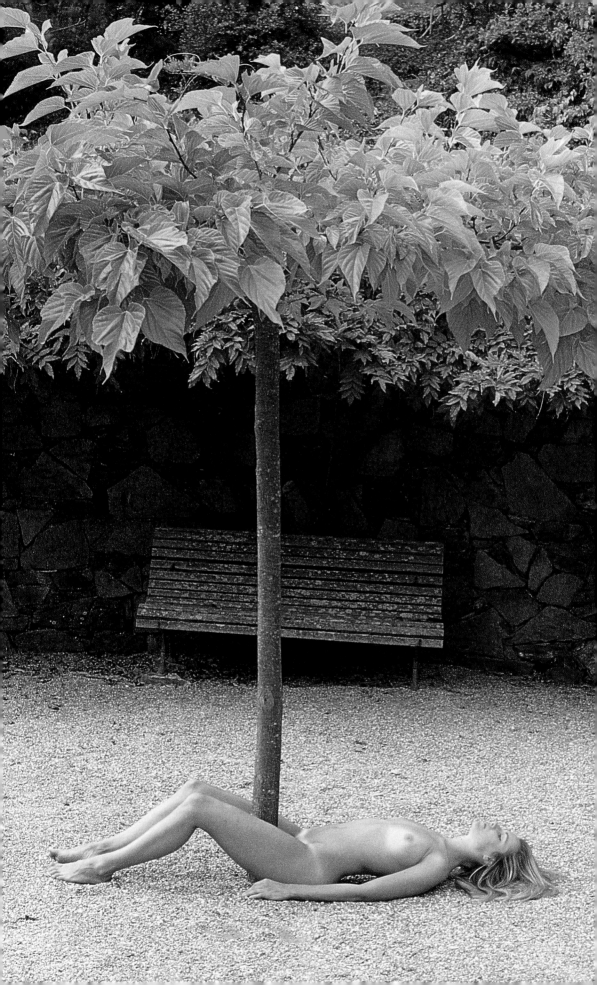

Framing and Viewpoint

WHEN PHOTOGRAPHING outdoors on location, you often have a rich variety of framings and viewpoints from which to shoot. Look carefully at the setting and make certain that there is nothing there that may detract from your image. Even a discarded piece of litter could spoil an otherwise perfect picture.

Immovable features in the landscape, however, such as a parked car, a distant power line, or a litter bin, may make it necessary for you to adopt a different camera viewpoint. If for some reason your viewpoint is fixed, then adjust the framing of your shot by using a different focal length lens. The angle of view of a long lens, for example, may remove the offending object altogether, or (if a large aperture is used) render it so indistinct and out of focus that it does not register.

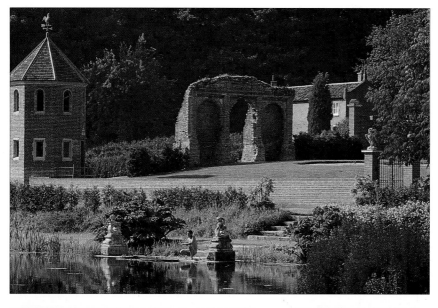

◁ **General view**
Taken from this viewpoint, and using the wide-angle end of a 28–70mm zoom, the subject and setting can be clearly seen, but there is a flatness to the composition. With no clear point of interest to anchor the viewer's attention, the eye wanders over the scene seeking some feature to rest on.

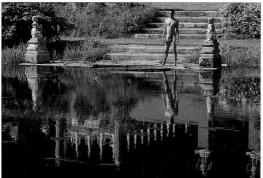

△ **A change of framing**
Zooming in for this shot, using the moderate telephoto end of the zoom range, has removed much of the background clutter, giving the composition a clear center of attention. By moving the subject close to the top of the frame, much better use has been made of the reflective qualities of the calm lake waters.

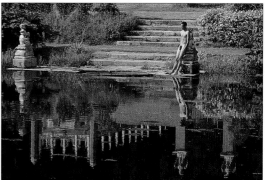

△ **Slight adjustment**
Apart from the subject's change of pose, the only difference in this shot is a slight adjustment of framing achieved by shifting the camera to the right. This brings the far cherub closer to the edge of the frame, which makes for a tighter composition. More, too, can now be seen of the attractive yellow shrub in the middle distance.

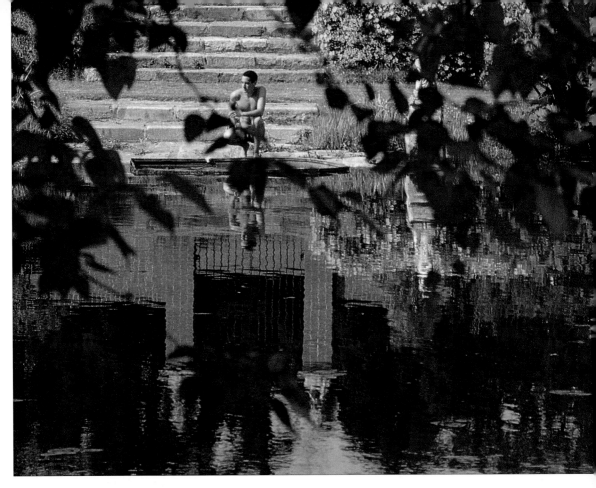

△ Radical shift in viewpoint

Shifting the viewpoint, as in this version of the scene, is perfect when you want to frame the subject using features in the found environment while, at the same time, obscuring anything in the lens's field of view that may be distracting. The lens aperture and focal length determine how out of focus the foreground will appear.

△ Not bold enough

In this version of the shot, a similar technique to that seen above has been used. However, the framing has not been bold enough and only a little of the tree's branches has been included toward the top of the picture. The result is more of a distraction than anything else.

△ Subject pose

When photographing distant subjects, such as the man in this picture, it is impossible to talk them through every change of pose. Basically, you have to allow them to move about quite freely within a predetermined area and then adjust the camera viewpoint and framing as the session progresses.

Outdoor Settings

THE VERY nature of figure and form photography dictates that outdoor backgrounds are often rather simple affairs – natural backdrops, domestic garden settings, or other types of location where you can work away from the curious stares of on-lookers. You must also always ensure that the setting and subject work harmoniously together. Many potentially winning photographs are spoiled because the setting assumes too much prominence and there is some doubt as to the main subject.

Unless your secluded garden is one that offers a good variety of different backgrounds and settings, you will need to scout some likely locations in advance of any photographic session.

Alternatively, you may know of public woodland, out-of-the-way areas of large parks, or lakesides and coasts that are not heavily used. An early-morning start should ensure that you have an hour or two of photography before any members of the public are likely to be about.

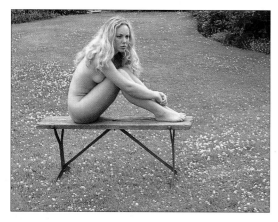

△ **Domestic garden setting**
The outdoor setting used for this shot is an average-size back garden. I had to select the camera angle carefully to avoid showing a garden shed and the edge of a patio in the frame. Another approach would have been to raise the camera height to close down the background.

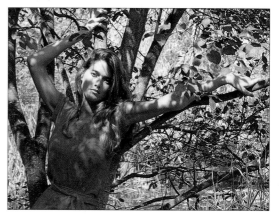

△ **Anchoring the viewer's eye**
The structural quality of the tree in this woodland setting made it an obvious backdrop for the model to use. And by adapting her pose to echo the shape of its branches, the eye is effectively anchored in the foreground, despite the off-center framing of the subject.

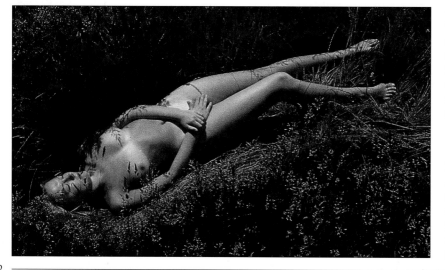

◁ **Farmland fringe**
This grassland nest is on a small piece of wasteland sandwiched between two large wheat fields. The camera angle gives nothing away.

▷ **Natural screen**
An impenetrable screen of tall foliage effectively isolates the figure from any unwanted distractions in the wider setting.

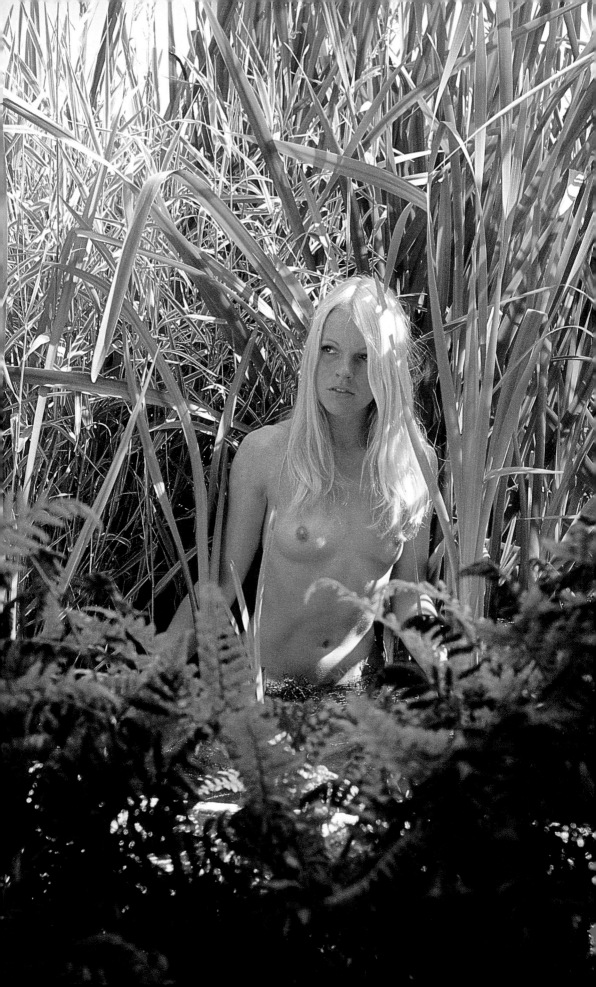

Altering the Familiar

BY TAKING something as familiar as the human body and then presenting it in a form that is only slightly altered from normal, you may create more visual interest for the viewer than if you had radically altered the subject's appearance.

There is always the risk that an image that deviates too far from reality may alienate its audience and, thus, have little impact. But by leaving the underlying figure recognizably intact, you are likely to produce an image that has a broad audience appeal.

The photographs here, and the one overleaf, fall into this category. The refracting qualities of the swimming pool water has shifted the figures sufficiently from the norm to amuse and intrigue, without abstracting them beyond all recognition.

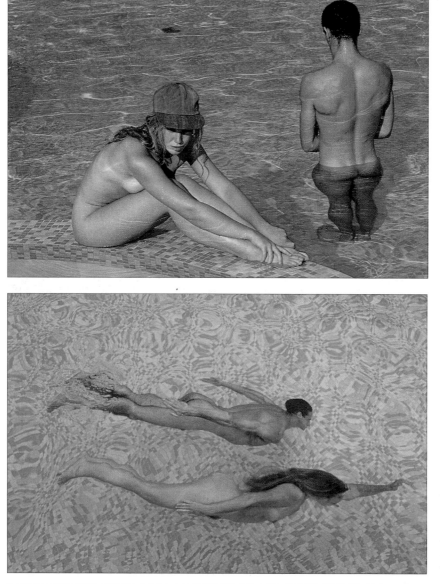

◁ **The session develops**
What initially attracted me to take these pictures was the strange refracting effects the water was having when the man was standing half in and half out of the water. As soon as they were both in the pool (*below left*) and swimming underwater I found the camera position where surface reflections caused me least problems.

▷ **State of flux**
The constantly shifting surface of the pool water meant that the shapes of the subjects were altering second by second – too fast, in fact, to decide consciously when to shoot for any particular effect.

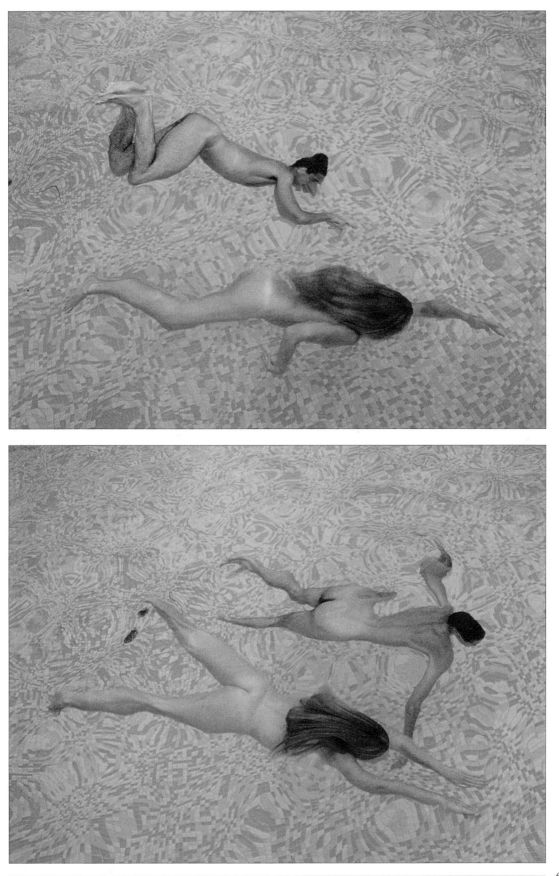

▷ Adjusting exposure

With a moving subject like this, you have to keep watching closely to see where you should be shooting from to record the best effects. As the two subjects swam under water, I had to move along the pool edges to keep up with them. This meant that the exposure was constantly fluctuating as patches of light and shade flickered briefly, and unpredictably, within the lens's field of view. In this type of situation, the almost instantaneous reaction time of an auto-exposure system is invaluable. Nearly all systems allow you to override the meter's reading by a preselected degree of under- or overexposure for darker or lighter results.

Accentuating Shape

IN ORDER TO accentuate one particular subject characteristic, such as shape, you usually have to suppress the appearance of others, such as form, texture, or pattern, to prevent them from competing for attention. Make sure that the subject's pose, the setting, and the lighting all combine to reinforce your aim.

The most obvious way to accentuate shape is by producing a silhouette (see pp. 36–7) in which all surface information is sacrificed in favor of the subject's outline. However, this is an extreme technique, and not generally applicable. In most situations, you can achieve the same goal by exploring camera angle and focal length.

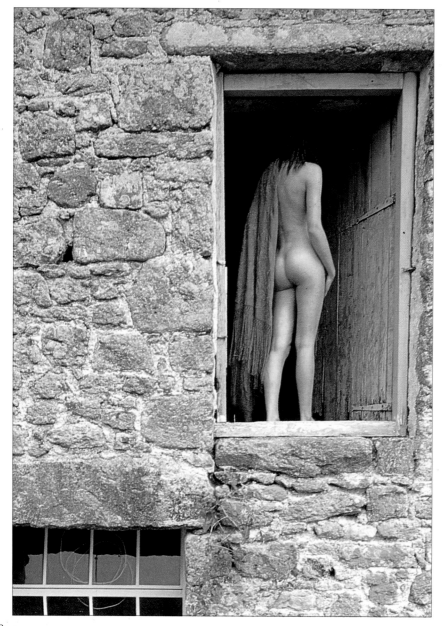

◁ **Contrasting shapes**

Photographs composed of many similar shapes often result in pattern being the dominant characteristic. In this shot, by positioning the model within the square frame of a doorway, surrounded by angular blocks of stone, the soft and rounded shapes of her body are sharply accentuated.

HINTS AND TIPS

■ Telephoto lenses can be used to accentuate shape by isolating small parts of the subject and excluding all extraneous visual information.

■ Wide-angle lenses can distort subject shapes when used close up, thus drawing attention to them.

■ High or low camera angles can exert dramatic effects on subject shapes.

▷ **Lighting contrast**
Lit by harsh, high sun-
light, the model here
is seen in blocks of
highlight and shadow.
There is very little
gradation of color or
tone, and this helps
to accentuate shape
rather than form. Even
the shapes of the
paving stones in the
immediate foreground
have been strength-
ened by being edged
with dark shadows.

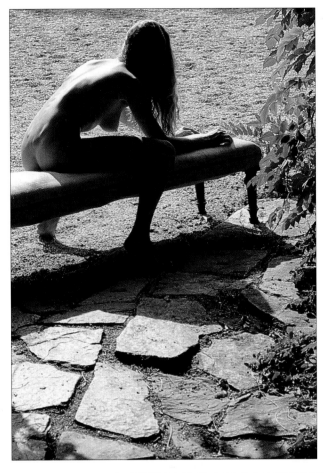

▽ **Lens and
viewpoint**
Taken a little later
in the day than the
shot on the left, and
with a change of lens
from 50mm to 28mm,
this photograph shows
the typical shape dis-
tortion that occurs
when wide-angles
are used close to the
subject. Note that on
the model's right leg,
where the light is more
dappled, form assumes
greater importance
than shape.

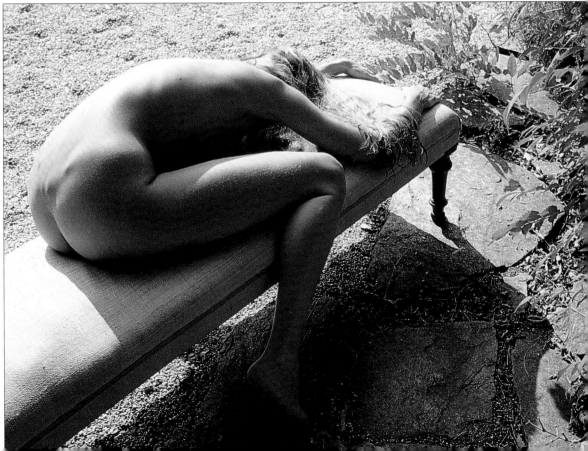

Timing the Shot

ANTICIPATION AND QUICK reactions are two of the most important attributes of good photography. To time your shots properly, you have to know what you are trying to achieve in the photograph. Don't wait until you can see the action unfolding in the viewfinder, because then it will probably be too late to respond.

As you look through the viewfinder, keep taking quick glances above the camera in order to retain some peripheral vision. In this way, you will have at least a little time to ready yourself to take the picture.

Even though the tendency of modern camera design is toward 'auto-everything', which often makes creative picture-taking more difficult than with a manual camera, one of the most beneficial technical innovations is automatic film advance. First, the motor controlling film transport winds the film on after each exposure faster than you could manually (so the camera is always ready for the next shot); second, you don't have to take the camera away from your eye to wind the film on.

No matter how carefully you time your shots, take more pictures than you think you will need and select the best ones afterward. The extra film costs are a lot less than arranging a new photo session.

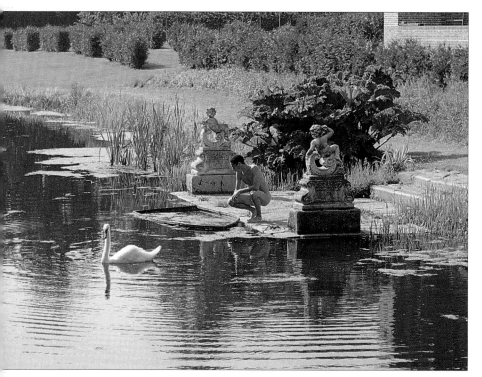

△ **Difficult subject**
Obtaining a photo-
graph of the model
and swan relating well
to each other when
seen in the camera's
viewfinder proved to
be very difficult
because of the unpre-
dictable nature of the
swan's movements.

▷ **Patience pays off**
As the model shifted
his position, coming to
the side of the landing
stage, the movement
attracted the swan's
attention. As it swam
toward him, I held off,
timing the shot until
they both looked per-
fect in the frame.

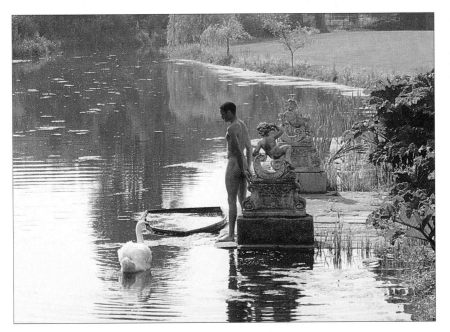

◁ **Problems continue**
I continued shooting at this point, even though I could see through the viewfinder that the swan and the model did not appear to be relating well. At any moment the inter-action between them could improve and I didn't want to miss the shot.

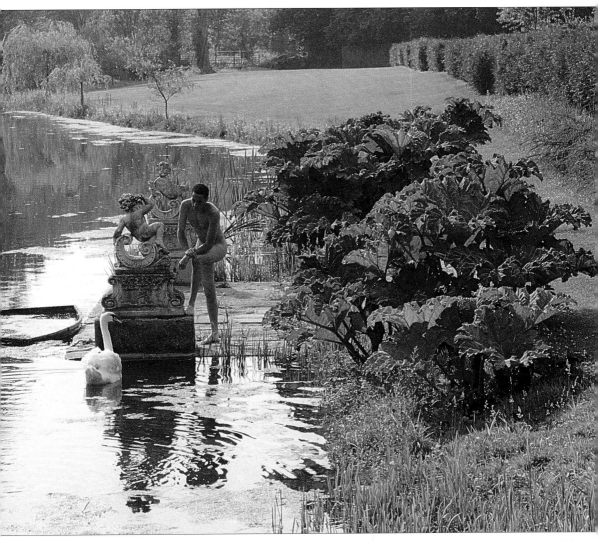

Lighting Contrast

WITHOUT A clear distinction between shadows and highlights, there is always the risk that a photograph may appear flat and unremarkable. If this distinction is extreme, however, the film may not be able to cope and subject detail will be sacrificed as a result.

Lighting contrast changes during the day. In early morning and late afternoon, a low sun ensures that shadows are well filled, so the exposure difference between shadows and highlights is not intense. Toward noon, however, a high, bright sun in a clear and open sky can create extremes of contrast. With lit and unlit surfaces juxtaposed, lighting can be harsh and unforgiving.

▷ **Subduing a background**
The contrast difference between the lit foreground figure and the shadowy background has been exploited here to produce an eyecatching composition. The exposure difference – 3 f stops – has created a strongly three-dimensional image.

◁ **Screen**
A screen of overhead foliage has softened the midday light here, and so the exposure difference between the shadows and highlights playing across the subject's face can be easily accommodated by the film.

▷ **Selective reading**
Camera settings suitable for the brightly lit water were used to expose this frame. The figure is 4 stops underexposed and has been reduced to a simple silhouette.

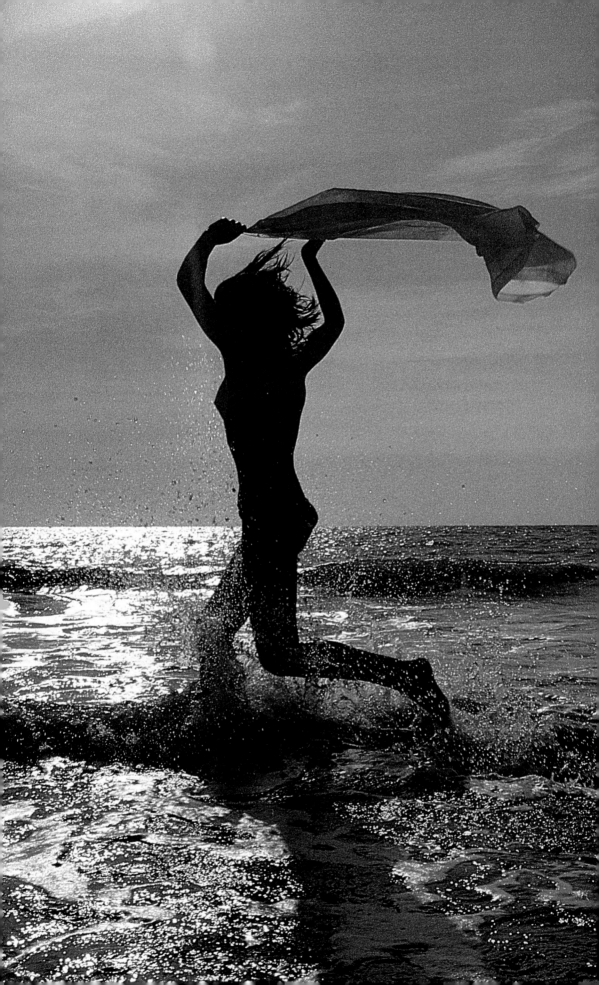

Candid Photography

I F YOU ARE working with models for a particular shoot, there should still be plenty of opportunities during a photo session to take some candid photographs. Photographs of people when they are relaxed and unguarded often have a refreshing naturalness, a quality that is often missing when the subjects are consciously posing for the camera.

Much of the day during any photographic session is taken up with positioning lights and reflectors, organizing rest periods, and other similar types of 'down time' for the models involved. It is during these breaks in shooting that they won't be paying any attention to you or to the camera.

The best approach in this type of situation, or when taking candid pictures of family and friends, is to use a long lens, or telephoto zoom setting – the further away from your subjects you are the less chance there is of them noticing you. If it is possible with your camera, it is best to wind the film on by hand between frames – many auto-winders and motor drives are noisy enough to attract attention.

If you can't distance yourself and use a long lens, and you have to shoot from close up, set as many of the camera's controls in advance as you can and lift the camera to your eye and shoot quickly when a likely opportunity presents itself.

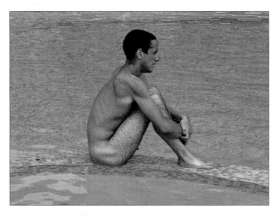

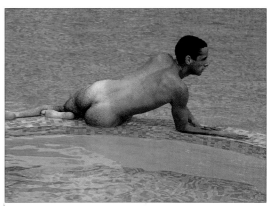

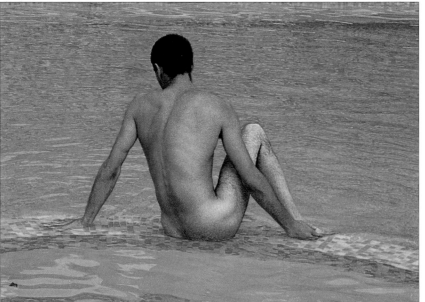

△ ◁ **Distracted subjects**
For this series of pictures, I was using a 135mm telephoto lens on a 35mm camera. For the initial shot, the man's attention was diverted by some activity on the far side of the pool. Since he had not noticed me taking the first shot, I carried on photographing him as he shifted around trying to get comfortable, before he settled down into the half-reclining position you see above.

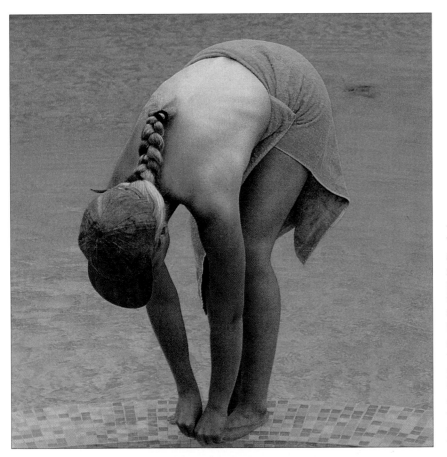

◁ ▽ **Lunch break**
The opportunity for another set of pool-side candid pictures presented itself during the session lunch break when the model became attracted by something she saw in the water. The shot I particularly like is where she is bending over using her hands to stop her heavy braid of blonde hair falling forward.

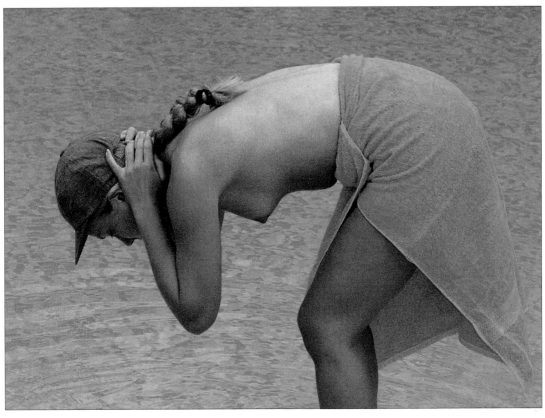

Subject Movement

THERE ARE TWO basic approaches to photographing moving subjects. First, you can select a fast shutter speed so that the subject appears to be frozen in mid-movement. Second, you can go the opposite route by selecting a slow shutter speed and allowing the subject to change position while the shutter is open and, hence, appear to blur on the film.

The first option allows you to see movement in an interesting, but unnatural, way, since it doesn't correspond to normal vision. Slower shutter speeds produce results closer to normal vision, and can be very evocative.

It is not possible to give precise shutter speeds to produce either of these effects, since much depends on the speed of the subject and the direction of movement in relation to the camera. Remember, you have to compensate for the shutter speed used with an appropriate lens aperture.

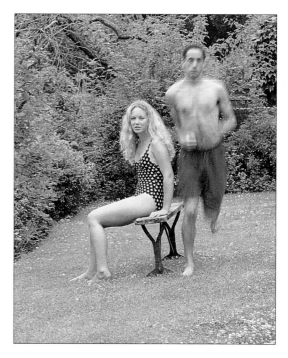

△ **Blur and frozen**
By including both a moving and a stationary figure in the shot, you can produce an interesting mixture of blur and sharp detail. To show this much blurring on a figure jogging toward the camera, a shutter speed of ⅕ second had to be used.

△ **Movement across the camera**
When a subject is moving across the field of view of the camera, you need to use a faster shutter speed to freeze movement than you would if he were moving toward or away from the camera. Here ⅟₁₂₅ second was used.

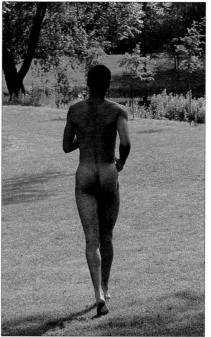

△ **Movement away from the camera**
Although the model was moving at about the same speed as in the previous shot (*above left*), here a shutter speed of only ⅟₆₀ second was need to stop all traces of movement.

HINTS AND TIPS
■ Subject movement toward and away from the camera can be frozen using a comparatively slow shutter speed.

■ Subject movement at 90° or 45° to the camera needs a relatively fast shutter speed to avoid blurring.

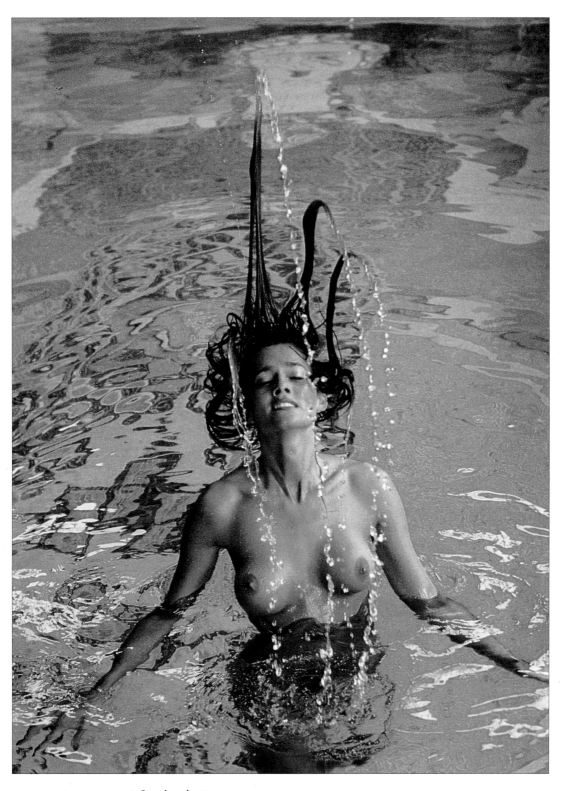

△ Creative shutter

The movement-stopping power of very brief shutter speeds can open a whole range of new creative photographic opportunities. A shutter speed of $\frac{1}{1000}$ second was used to transform the stream of water being flicked from the model's hair into a string of perfect bead-like globules. When fast shutter speeds are used you often have to set wide apertures to ensure correct exposure, and this may result in too shallow a depth of field.

Lens Effects on Background

Photographers usually have a selection of different lenses, ranging from wide-angle to telephoto, to suit different picture-taking situations (or a zoom lens covering the same range). For example, a telephoto lens is ideal when you want to bring the subject up large in the frame while shooting from some distance away – perhaps when taking candid shots (see pp. 74–5).

Wide-angle lens are often used when you want to show the subject in a broad landscape, or when you are shooting in a confined space and you cannot move far back from the subject. Although they can create unflattering distortions if used too close to the subject, a 35 or 28mm lens is ideal for making a model's arms or legs appear slightly longer and more elegant.

However, bear in mind that different lens focal lengths have a marked effect on all of the image – the foreground, middle distance, and background – not just on the main subject, as the comparative pictures here demonstrate.

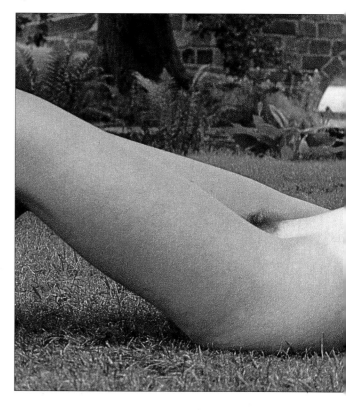

▷ **Telephoto lens and background**
For this photograph, the model was positioned on an area of grass leading to a distant bridge. The lens was an 80–210mm zoom set to about 180mm. The featureless middle ground has been swallowed up and note, too, the size of the bridge in relation to the figure.

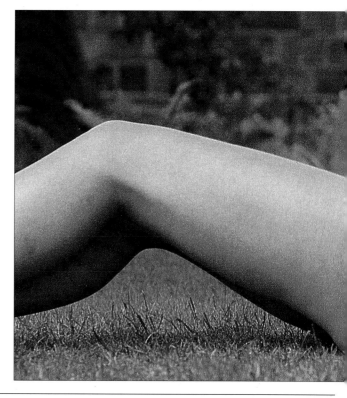

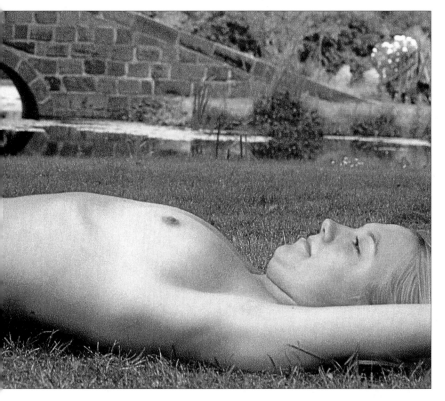

◁ **Wide-angle lens and background**
To take this version of the subject featured below, a 35mm moderate wide-angle lens was used. In order to see the figure as approximately the same size in both shots, the wide-angle lens was used much closer to the figure. The particularly interesting feature of this picture is the apparent size of the background bridge in relation to the foreground figure. Compare this with the shot below.

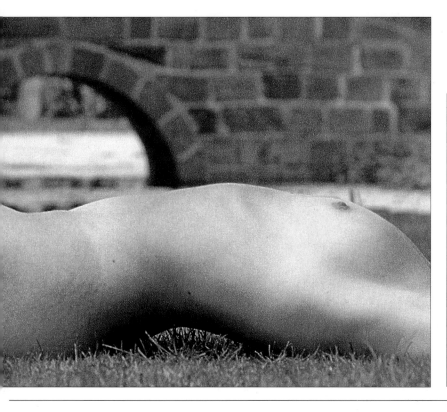

HINTS AND TIPS
■ A telephoto lens can emphasize the background of a picture. Make sure this is what you want to happen.

■ A wide-angle can render background elements too small to be recognized – a useful way of suppressing unwanted picture elements.

■ Use a wide aperture on a telephoto to make a distant background appear out of focus.

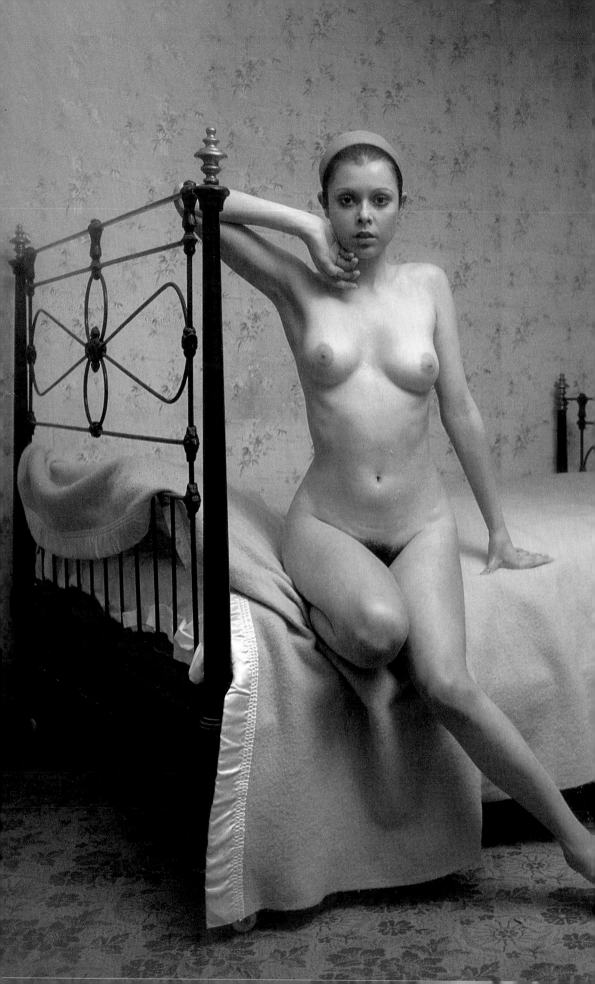

Creating
a Style

A S YOU BECOME more experienced as a photographer, then the purely technical aspects of lighting and selecting the best shutter speed and aperture combination for exposure, depth of field, and subject movement become more certain and reflexive. It is at this stage that you can begin to concentrate your attention on the aesthetic aspects of your work and develop a style that is readily identifiable as your own. This could be a particular approach to composition, your choice of lens and viewpoint, a preference for one type of lighting over the others, the atmosphere you produce, how you relate the figure to the setting, the form and sensuality you conjure, or your basic approach to the subject – either abstract or figurative.

Unusual Viewpoints

AN INSTANT and easily achievable way to give a different look to your photography is to find an out-of-the-ordinary camera angle from which to shoot. And the more exaggerated this viewpoint, the more impact your photograph could potentially have. However, shooting from an unusual viewpoint is, in itself, no guarantee of successful pictures unless that viewpoint adds a new dimension to the subject or the setting.

When assessing the photographic potential of a particular location, look for shooting positions that allow you to get the camera well away from the subject's eyeline – either above or below it. Outdoors, you may be able to take advantage of sloping or uneven terrain, or you may be able to shoot from the roof of your car, a convenient fence, or even a sturdy branch of a tree. In a garden setting, you may be able to shoot down on your subject from an upstairs window, or reverse the situation and shoot up at your subject from somewhere in the garden beneath.

If you are photographing indoors, use landings (especially galleried landings) or half-landings in stairways – these are excellent since they give you the opportunity to position yourself either well above or below your subject.

Adopting an unusual viewpoint often results in quite ordinary objects in the setting taking on an intriguing appearance, such as the radiators at the bottom of the stairwell in the photograph opposite, for example.

▽ **Viewpoint and lens**

Shooting from a half-landing in a stairwell, in the first shot (*below left*), the subject is far enough away from the camera for the 28mm wide-angle lens to record a normal-looking perspective. However, for the second image (*below right*), the subject moved closer to the camera and the lens has exaggerated the steepness of the viewpoint by creating some foreshortening in her rear leg.

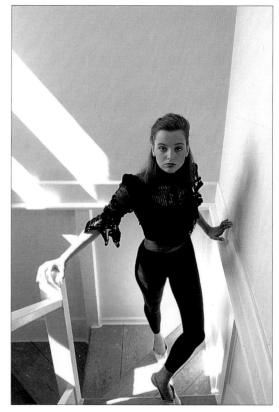

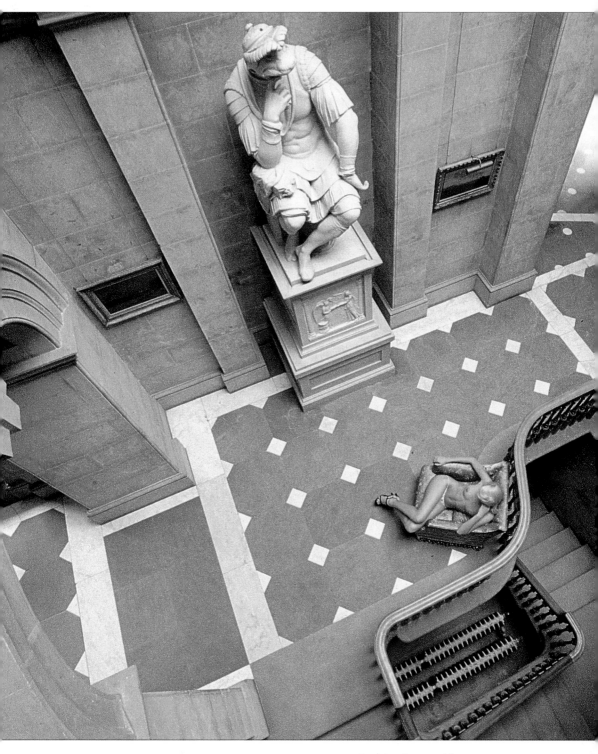

△ **Amusing juxtaposition**
A camera position high up in a galleried
landing overlooking the vestibule of this
building was the best way to record this
light-hearted scene of the seated statue
apparently contemplating the near-naked
model lounging opposite him with some
degree of seriousness.

Using Reflections

PHOTOGRAPHERS OFTEN use reflections within the image area to add an extra dimension to their work. Depending on the surface in which the subject is reflected, you can create effects ranging from the intriguingly ambiguous to the totally abstract.

Glass has the property both to reflect and transmit light at the same time. By choosing your camera angle carefully, you can show not only any subject you position behind a sheet of glass – in, say, a window – but also the reflected image of the scene in the direction of the camera. Be careful not to include your own reflection accidentally in the glass.

Good-quality glass will reflect or transmit virtually distortion-free images; use poorer-quality, or patterned, glass to produce more abstract, carnival-like images.

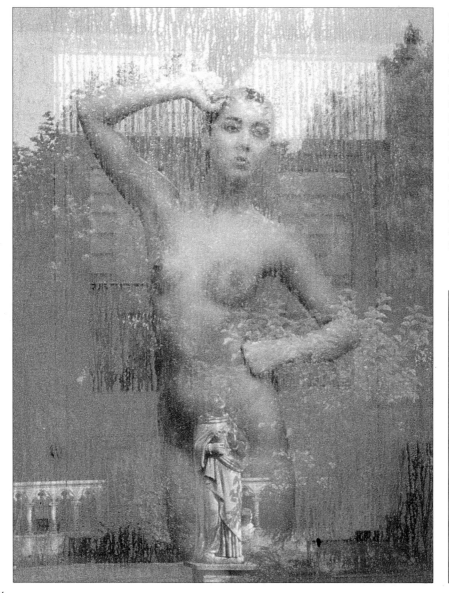

◁ **Ambiguous imagery**
The condensation on the inside of this window acts like the silvering on the back of a mirror, producing a strong, reflected image overlaying that of the model. But the layer of condensation is not even, so the clarity of the reflected image varies. The effect is like looking at all the planes of a scene in just one thin surface.

HINTS AND TIPS

■ Shoot at an angle, not flat on, to the surface showing the reflection to avoid accidentally including your own image in the photograph.

■ You may have to use a small aperture to ensure that there is enough depth of field to record both the subject and reflection sharply.

■ Use a polarizing filter to remove unwanted reflections from glass surfaces.

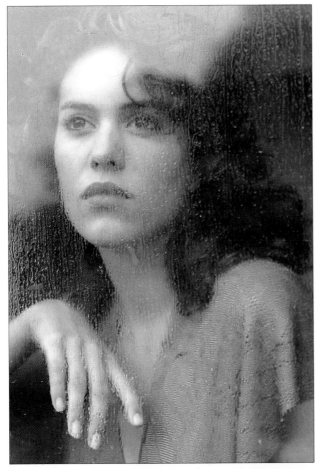

◁ Pensive pose

Rivulets of water running down the outside of the window have formed ribbons of texture overlaying the subject. This texture is most noticeable in areas where the skin tones are visible – on the model's face, neck, and hands. The bright reflection, cutting diagonally across her face, hints at the scene beyond the camera toward which she is pensively staring.

△ Limited depth of field

A moderate telephoto lens (105mm on a 35mm camera) combined with a wide lens aperture (f4) have reduced the depth of field to the point where the subject's reflection in the mirror behind is soft and blurred. A sharply recorded reflection in this situation would have distracted attention from the subject.

▷ Disembodied reflection

Here, the reflection in the mirror has been used without us being able to see the subject directly. The poor quality of the mirror's silver backing produces a patchy image, not unlike that of an old painting – an effect that is amplified by the mirror's elaborate gilt frame. The paintings behind the model enhance the slightly unreal mood of the photograph.

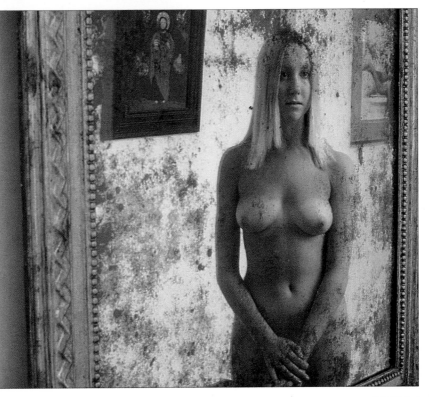

Shadow as a Pictorial Element

HE ABSENCE of light, or a diminution of light in comparison with surrounding areas of the subject – in other words, shadows – can be used as vital components of your picture.

Shadows cast onto your subject so that they wrap around the person, distorting as they follow the body's contours, can help to define shape and form. Areas of undistorted shadow overlaying the subject can transform an ordinary composition into an intriguing abstract design; while shadows cast by your subject onto nearby surfaces can create interesting double images as well as provide spatial clues about the subject in relation to his or her surroundings.

Depending on what has formed the shadows, strange color casts may sometimes appear. Sunlight filtering through foliage, for example, may project a green-tinged shadow onto your subject.

▽ **Harsh shadows**
Direct sunlight shining through venetian blinds casts hard bars of shadow across the model's body. Seen in detail, this type of shadow tends to abstract the subject.

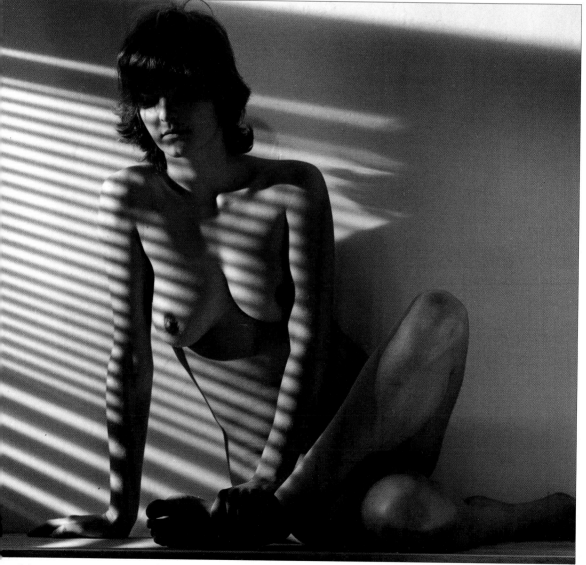

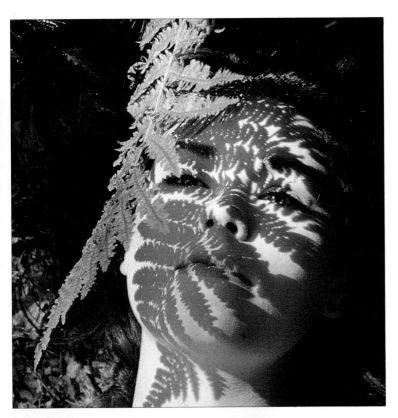

◁ **Colored shadows**
Held directly above the model's head, this fern is sufficiently translucent to transmit the sunlight striking it, coloring it green before imprinting itself on her face. When the object casting the shadow is out of the image area, the presence of colored shadows can be even more intriguing.

▽ **Shadows that define**
Shadows from a lace panel held over a window project light-toned shadows onto the subject, following her every contour and emphasizing the soft, rounded planes of her body.

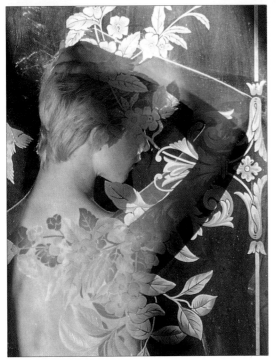

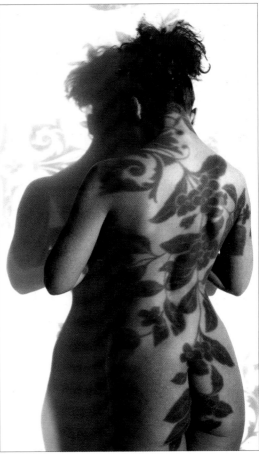

△ **Layered shadows**
Not only is the etched glass pattern strong enough to cast shadows over parts of the model's figure, her body is also throwing a shadow onto the rear wall, creating a multi-layered effect that demands attention.

Visual Communication

A S YOU BECOME more used to directing your subjects to adopt particular poses in front of the camera (*see pp. 26–7*), you should start to realize the potential that exists for your subjects to communicate specific moods and attitudes. Their facial expressions and general body language can be used to create the type of atmosphere that will give your pictures that vitally important eye-catching appeal.

It may help if you think of your models as a director thinks of the actors and actresses on a film set. If you want to elicit specific responses from them, then you must give them a role to play and a context – a storyline, if you like – in which that role makes sense to them. Experienced photographic models are well used to this type of role playing and can convincingly communicate a wide range of emotions and attitudes, switching roles virtually from

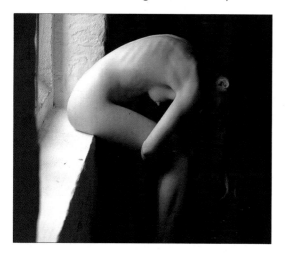

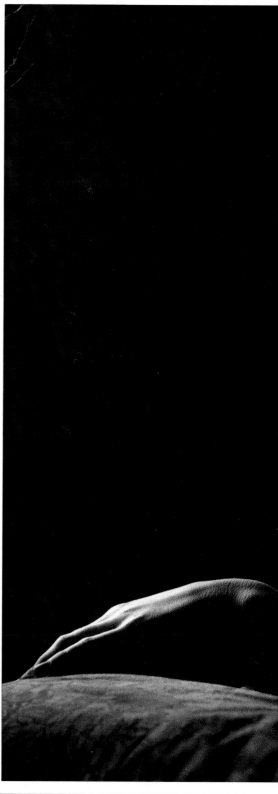

△ **New model**
If you are working with inexperienced models, encouraging them to role play in front of the camera can be difficult. If a model's facial expression proves to be the problem, then start the session with some poses in which the face cannot be seen.

▷ **Real setting**
Sometimes it is better to work in a real setting, such as the bedroom here, rather than in a studio set. Complementing the moody light perfectly, this model manages to give the impression of being entirely alone with her thoughts.

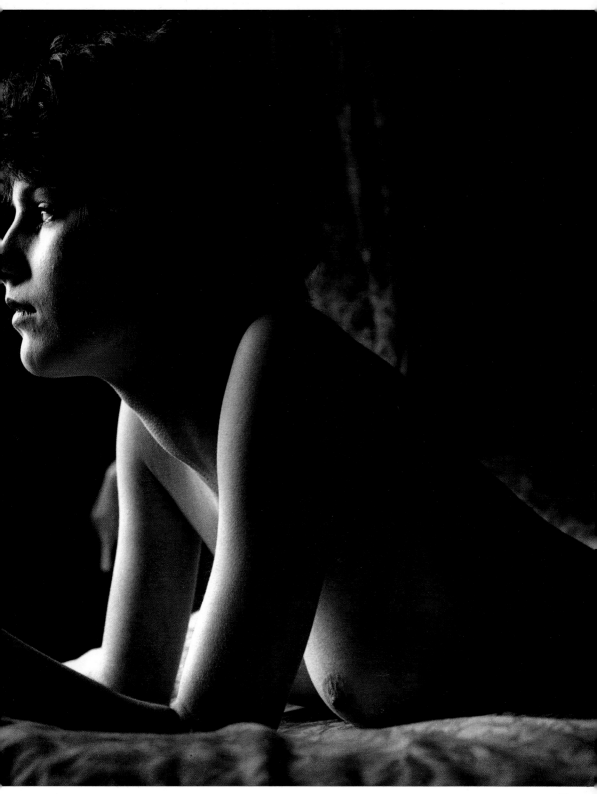

frame to frame. Less-experienced models, however, will need more time to adapt and compose themselves. Show them pictures from magazines or books of the type of poses you want to see them adopt for the camera.

The photographer's role in this is crucial: any awkwardness or hesitation on your part will be communicated instantly to the models and may spoil your chances of a successful session.

As you set the lights, explain what you are trying to do. Once they are in position and you have made any last-second adjustments to the set or your camera position, start to shoot while you continue to monitor them through the camera's viewfinder. Always stay in control of the session by coaching and encouraging them to respond in the way that you require.

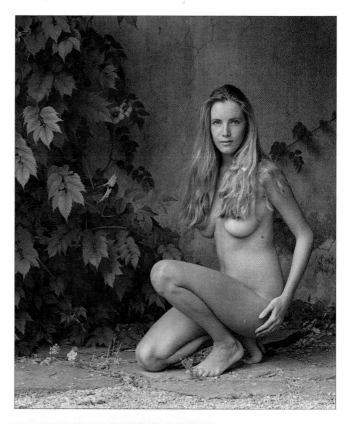

△ **Eye contact**
Having the model stare directly into the camera lens is a trick often employed by photographers to engage the attention of the viewer. Here, the model's confident expression and posture are accentuated by her hand resting comfortably on her thigh.

▷ **Important detail**
The similarity in pose between this picture and the one above is striking, yet they are communicating very different stories. The distress in the man's face is obvious, something that has been emphasized by the hand holding his thigh. Far from appearing comfortable, as above, he is full of tension and anxiety.

▷ **Body language**
Simply by allowing his shoulders to droop and his body to sag, this model has managed to impart a sense of despair that requires no facial expression to be seen.

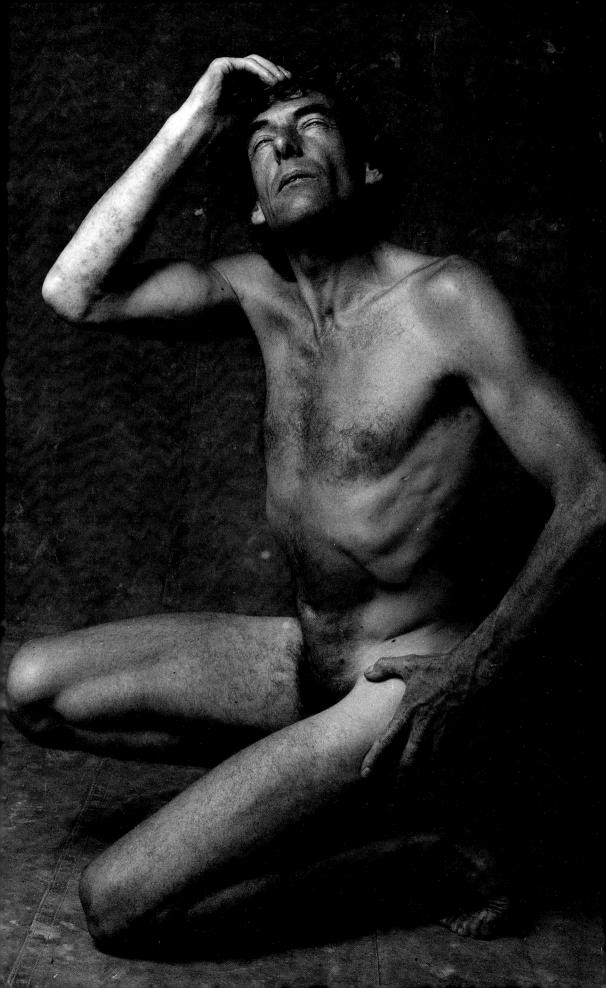

Introducing a Humorous Note

WHEN YOU are submitting photographs to be judged in a competition or sending them for publication – or even if you are simply putting together a slide show for family and friends – one way of making people take note is to include a few humorous images. Once an image has caught the attention of your audience, they are more likely to look at it properly.

One type of visual humor is to show the human form in a particular way or from an unlikely viewpoint so that it differs from our normal perspective. Another technique is to use what is known as 'false attachment'. This is when, through a quirky alignment, your subject appears to be attached to another element in the background, middle ground, or foreground of the picture.

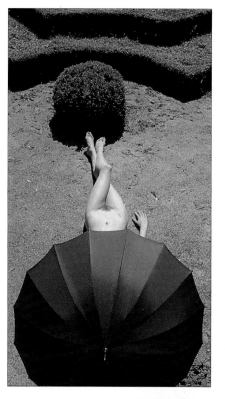

◁ **High viewpoint**
By adopting a high camera angle looking directly down on the subject, the deep blue umbrella neatly cuts off all view of the subject from the head to the waist. The remaining part of her body is then seen to be sandwiched between the umbrella and the pruned hedging shrub at her feet.

▽ **Unusual perspective**
The brightly painted red nails of the model's hands and feet, shot against a totally isolating background, present a bizarre spectacle.

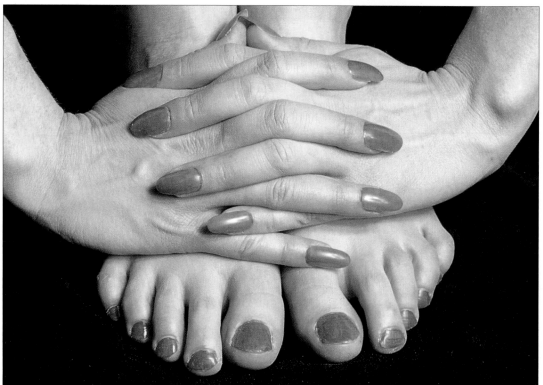

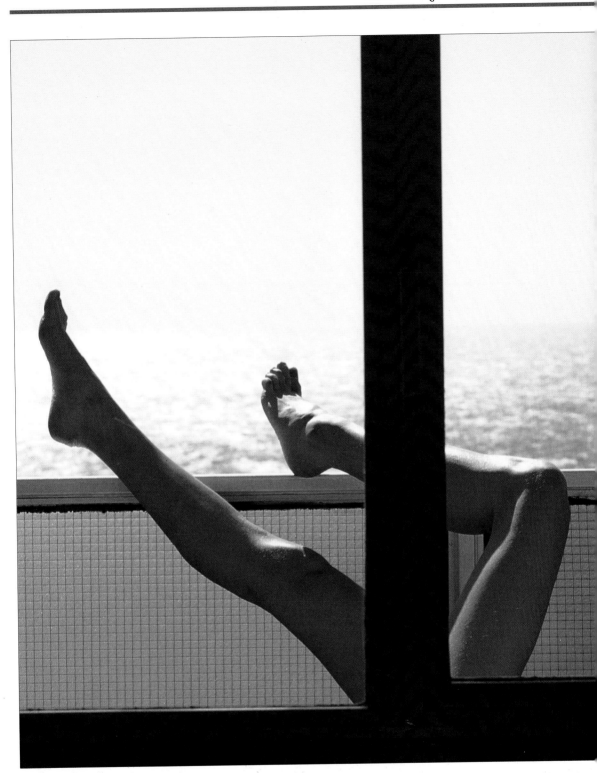

△ **False attachment**
By aligning the vertical window frame and the little we can see of the subject, it appears as if her legs and the frame are physically connected. The humorous content of the composition is strengthened by including the bottom of the frame, which appears to have absorbed the hidden part of the subject.

Color Composition

PHOTOGRAPHIC COMPOSITIONS in which the color content has been carefully considered can have an arresting quality.

One way of classifying colors is to divide them into 'warm' or 'cool' hues – a classification that denotes mood as well as temperature. Warm colors come from the red, orange, yellow end of the spectrum and, visually, they seem to advance in the frame toward the viewer. At the other end of the spectrum are the cool greens and blues, and these colors appear to recede in the frame.

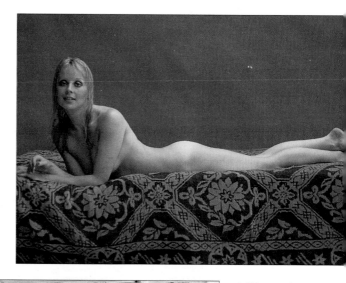

△ **Warm colors**
The red-painted background of this studio set seems to envelop the model lying in front of it, creating an atmosphere of warmth and intimacy.

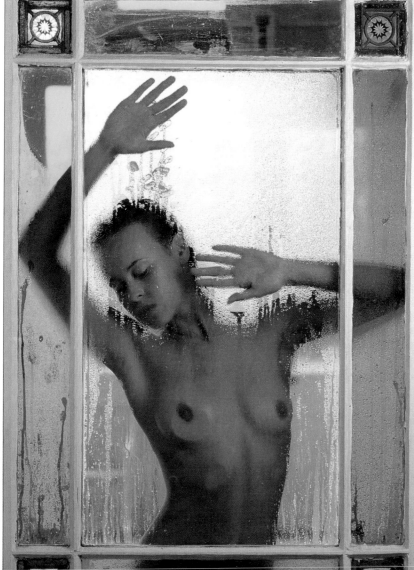

◁ **Color harmony**
The gold glass border of this bathroom door makes a harmonious frame for the model pressed against the glass. Note that where her skin shows through the gold its color takes on the appearance of the brown-painted areas at the top and left-hand corner.

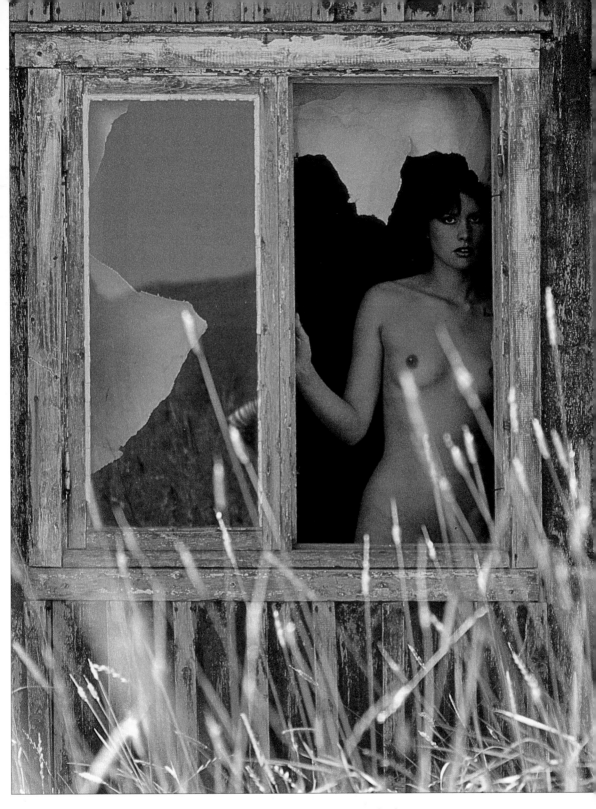

△ Cool colors
Some films have a color bias toward blue, especially in the shadows. I took advantage of this fact by creating a predominantly cool-colored composition, which, when combined with the dilapidated state of the building, has an air of menace about it.

Working with Couples

IT IS NOT uncommon for photographic models to work with friends or people they know well when shots of couples are required. For convincing photographs, it is important how your models react and respond to each other, and that their poses seem genuinely natural and free from any awkwardness, especially when they have to make physical contact.

When lighting couples in the studio, or if you are working outdoors using daylight, perhaps supplemented with flash, you need to pay particular attention to the fall of shadows, since it is very easy for one of your subjects to cast unattractive shadows across the other.

You also need to bear in mind that two people will cast separate sets of shadows on to the set or their surroundings, and unless the main lights are set so that these shadows fall in the same direction any illusion of natural lighting will be destroyed. When working with studio flash, use the modeling lights to check this before shooting.

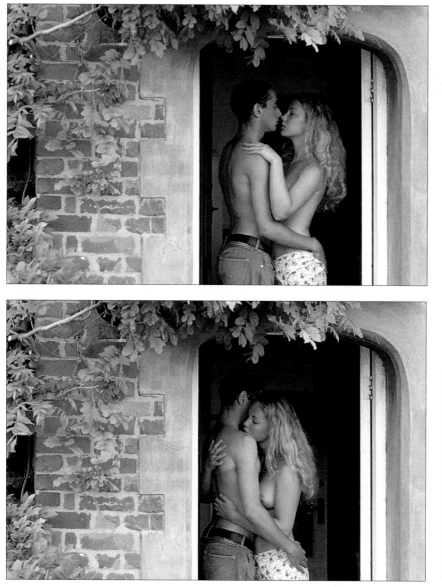

◁ **Experienced couples**
This man and woman were used to working with each other in front of the camera. With the minimum of coaching they adopted the poses required of them, and it is easy to see in these two photographs that they are completely relaxed making physical contact.

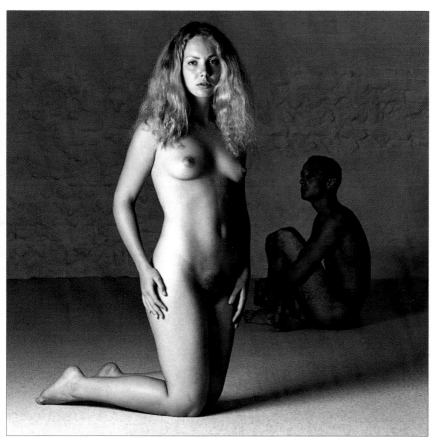

◁ Emphasizing distance
By setting the lights so that the man is in shadow and the woman is fully lit you create the feeling of heightened distance between them, not only in space but also in mood. Note, however, that the shadows from each are falling in the same direction.

▽ Easy steps
Until your models become accustomed to making physical contact with each other, take the photo session in easy steps and don't make un-reasonable demands. This affectionate portrait required only minimal contact.

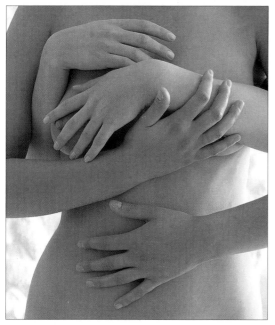

△ Whose hands?
Cropping in tight and completely obscuring the body of one of the subjects has resulted in a humorous composition in which it is difficult to distinguish which hands belong to which model.

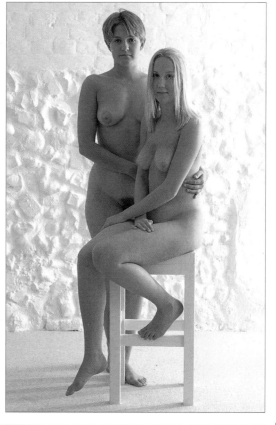

Soft-focus Effects

ONE RELATIVELY easy way to give some of your photographs an eye-catching and distinctive style is to use one of the range of soft-focus effects. As with all special effects, however, be careful not to overuse them since they can rapidly lose their impact and become monotonous.

Soft-focus techniques are most often used when you want to produce photographs with a gentle, romantic or mysterious atmosphere in which the subject, although clearly discernible, does not have the clinical sharpness good-quality modern lenses are designed to produce. Some lenses, most often short telephotos, are manufactured specifically to give slightly soft images, but the usual technique is to screw a soft-focus filter to the front of an ordinary lens, or to photograph the subject through some sort of fine, translucent material held very close to the lens. The material will then be so far out of focus that it cannot itself be seen, but its presence scatters enough of the light entering the lens to soften the edges of the recorded subject.

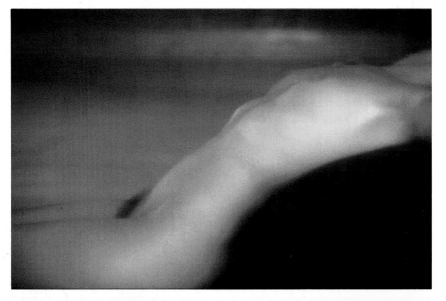

◁ **Fine gauze**
By stretching a piece of fine gauze material over the camera lens the subject has been recorded as a soft-focus image. The lens used, a 210mm telephoto on a 35mm camera, was set to a wide aperture (f4.5), and this ensured that the background was not only soft focus but also out of focus.

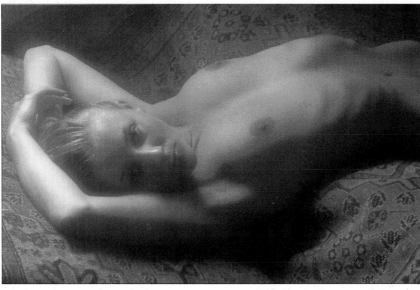

◁ **Soft-focus filter**
A plain-glass filter engraved with a series of fine lines was used to produce this soft-focus image. The effects of the filter become more pronounced the wider the aperture used.

▷ **Condensation**
The condensation on the inside of the glass in front of the model creates a crude soft-focus effect, but one that is very evocative.

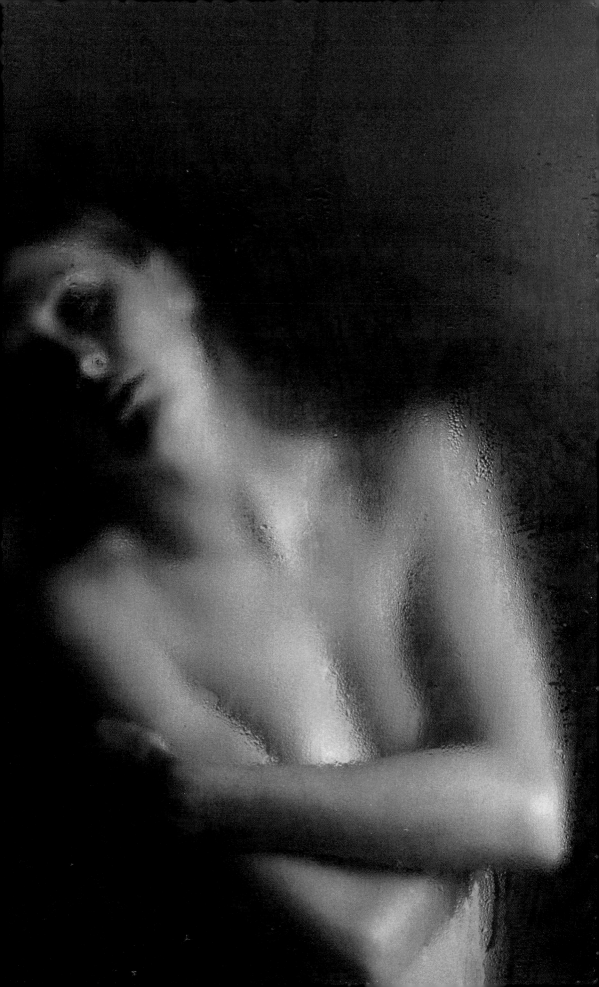

Problems with Daylight

Most problems photographers encounter when shooting in daylight occur when the scene or subject is composed of widely different exposure values – the subject, for example, may be in direct sunlight and require an exposure of, say, f16 at ½₅₀ second, while the background (or even a part of the main subject) may be in shadow and require an exposure of about f5.6 at ⅟₆₀ second. Overall, this represents a 4-stop difference in exposure between the shadows and highlights, which is beyond the ability of most film to record successfully.

In such a situation, the temptation may be to set a compromise exposure of f8 at ⅟₂₅ second, thereby overexposing the highlights by 2 stops and underexposing the shadows by the same amount, but results are still likely to be unsatisfactory. In general, it is better to decide which is the most important part of the subject and to set your exposure accordingly or, alternatively, move your subject or camera position so that exposure overall is more even, or use a supplementary light to brighten the shadows and so reduce contrast (see pp. 106–7).

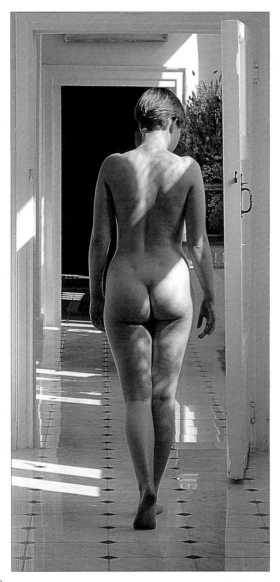

◁ **Prioritizing exposure**
The most important part of this image, in terms of exposure, was the bright area on the woman's back, neck, hair, and the side of her face, and exposure was set for this. The strong highlight on her right buttock and the shadow areas on the rest of her body were ignored and allowed to overexpose and underexpose respectively.

▷ **Moving the subject**
Initially, this model was posed sitting upright with part of her legs falling within the window-shaped highlight. This resulted in an impossible exposure difference between highlights and shadows. The change in pose to the one you see here meant that extreme contrast was turned into a positive picture element.

△ Interrupting the light

If the existing daylight is too bright for the type of image you want to record, try moving your subject behind an attractive backdrop or canopy of foliage so that the light filtering through is more dappled in quality.

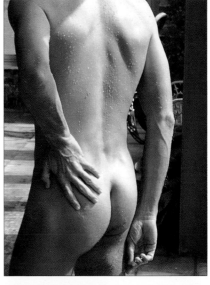

◁ Indirect light

A trick photographers often employ when they want to reduce light levels overall without flattening contrast completely is to move the subject out of the direct sunlight. Then, to add a little sparkle, they use a reflector (either one brought to the scene or a natural reflector such as a light-colored wall) to bounce light back on to the subject.

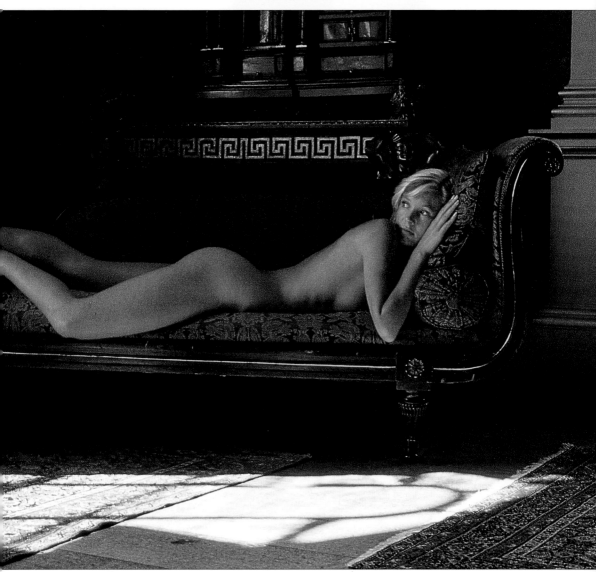

Smoke Effects

THE INCLUSION of smoke in a scene can serve a number of purposes. First, it can add some dramatic interest to what might otherwise be a rather prosaic scene. Second, it can help to divert attention away from an unattractive background or other feature that cannot be avoided by moving the subject or finding a different camera angle. Third, it can be used to diffuse over-harsh sunlight and produce a more flattering lighting effect. And fourth, it can soften image quality overall to take away some of the clinical clarity modern film is capable of recording.

Outdoors, build a small fire using green wood or foliage to produce smoke. Indoors you will need to use a special smoke machine, which can be hired from any large photographic store.

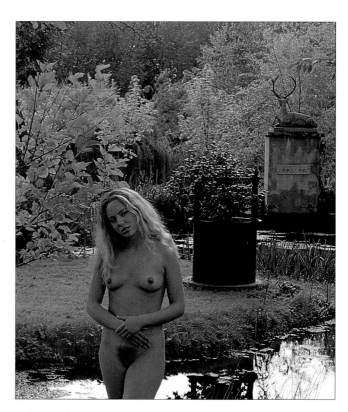

◁ △ Transforming a scene
The scene above shows a confusion of subject elements, with the foreground figure competing with the background for attention. Once smoke is added, however, the background overall is subdued without losing any of the charm offered by the wooded meadow setting and large pieces of garden sculpture.

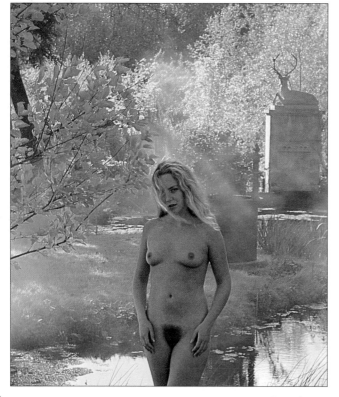

▷ Smoke machine
Consisting of an enclosed hotplate and a special liquid that, when heated, produces smoke, even a small smoke machine is sufficient to fill a small room. In order to achieve an even coverage of smoke, it is a good idea to use a small fan. One with a variable-speed motor gives you better control.

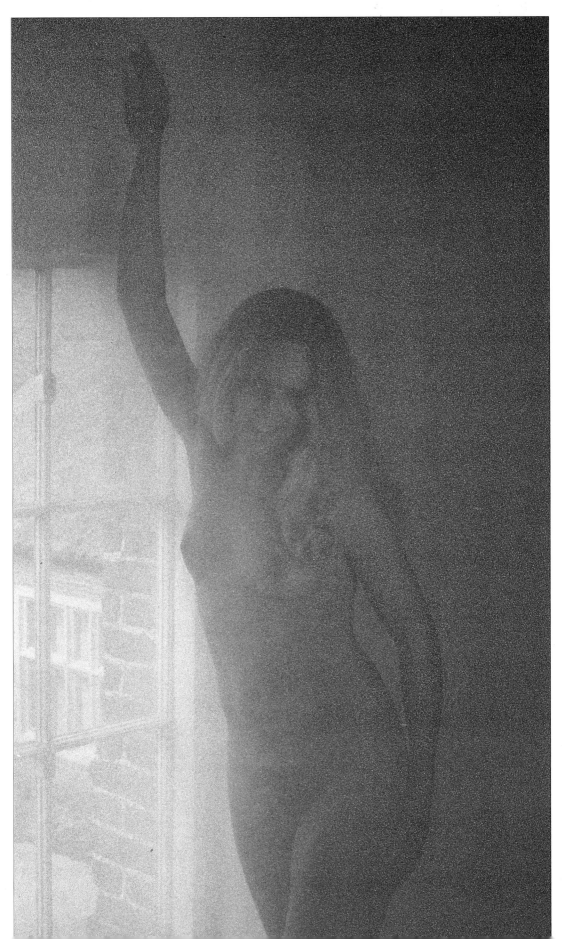

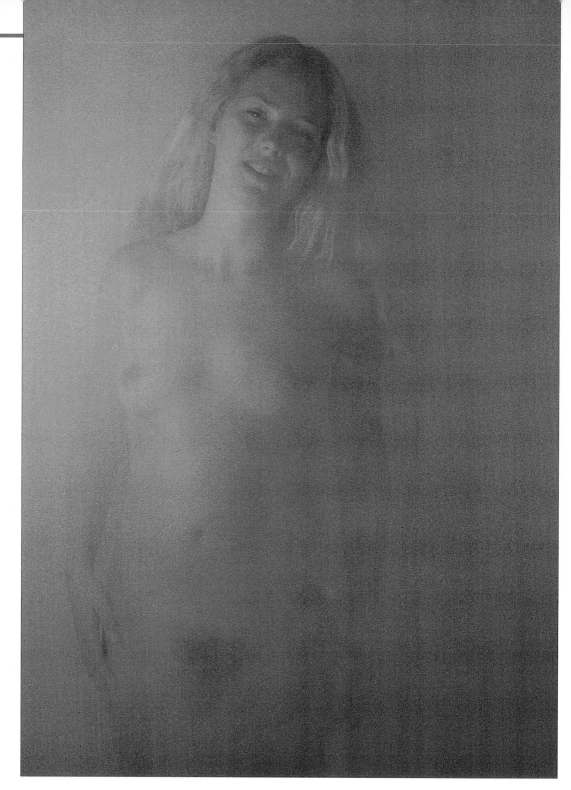

△ Color effects

By shining a light covered with a colored gel into a smoke-filled area you can bring the whole scene alive. Diffusing the light will produce more of an even color effect throughout the smoke, while an unobscured tight-beamed light, such as a spot light, will produce a core of intense color with a softer-colored periphery.

▷ Exposure warning

Like mist or fog, the minute particles making up the smoke tend to bounce any available light around. This can fool a camera's exposure meter into assuming that there is more light falling on the subject than there in fact is, resulting in underexposure. If in doubt, bracket exposures, giving ½ and 1 stop more exposure than the meter recommends.

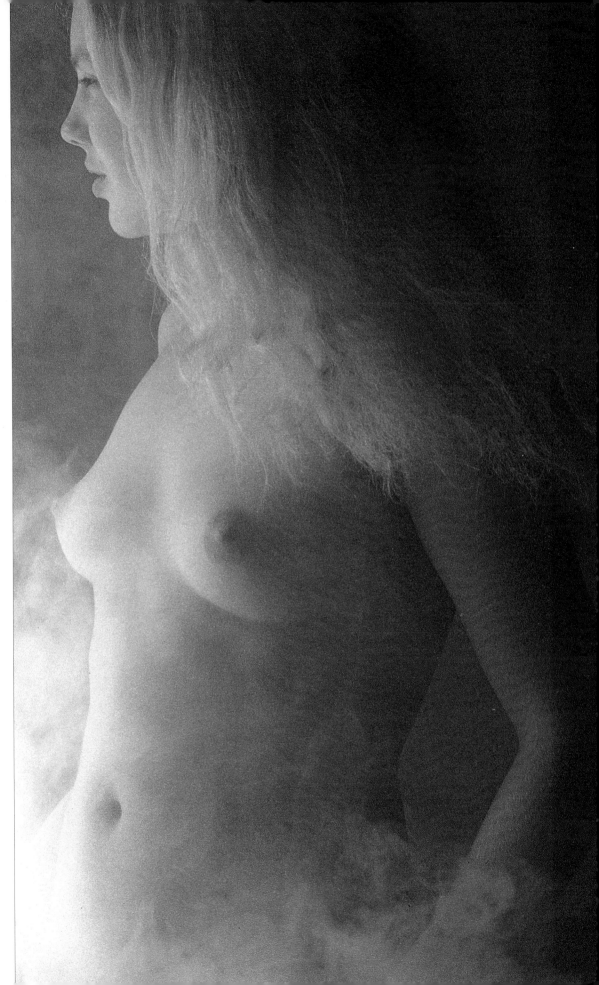

Supplementing Daylight

PHOTOGRAPHERS OFTEN have to supplement the levels of natural daylight that are available − both indoors and out. They do this not only when light levels are low overall, but also to decrease overly contrasty light.

In order to reduce contrast in a scene that is lit by daylight, it is often easier to add light to the shadows (rather than try to reduce the daylight reaching subject highlights) using a studio or camera-mounted flash unit or carefully positioned reflectors.

However, if contrast is flat and dull, you can also use flash or reflectors to add a little sparkle and vitality to important parts of a subject, such as the face and, in particular, the eyes. Studio or domestic tungsten light combined with daylight will result in color casts (*see pp.* 130-1) on color film.

▽ **Using a softbox**
The only natural light in this room was from a window on the camera's right and the side of the model away from the window was lost in shadow. To maintain the natural quality of the lighting, a heavily diffused softbox was used to the left of the camera.

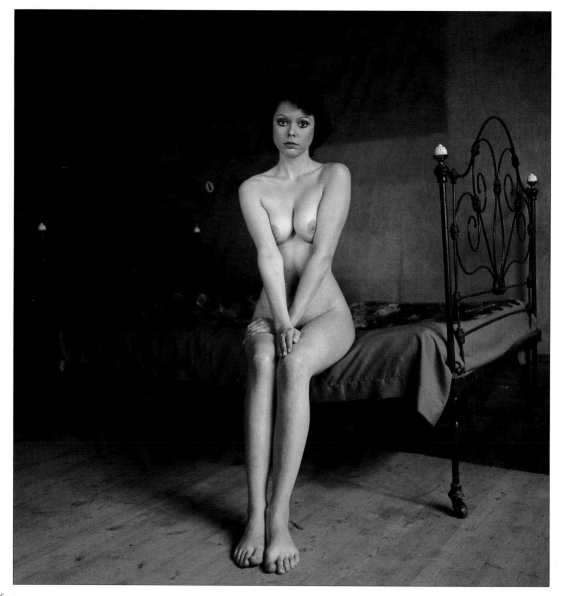

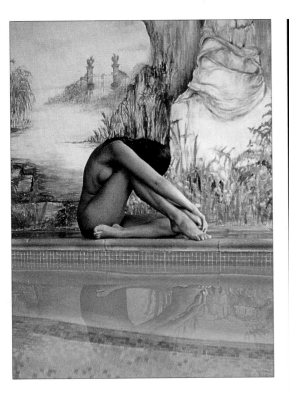

△ **Increasing contrast**
Although there was plenty of light around the pool, the model was in danger of merging with the painted wall behind. To overcome this, light from two large reflectors was directed on to the wall to brighten it a little.

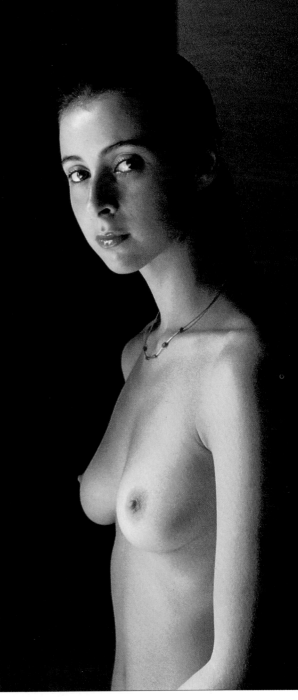

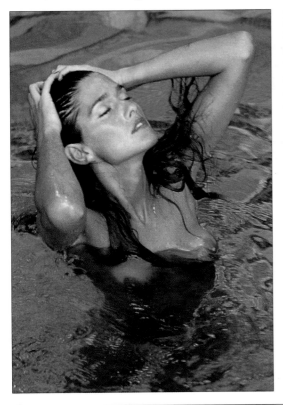

◁ **Accessory flash**
Here, again, light levels overall were not a problem, but camera-mounted accessory flash was directed at the model to add sparkle to and enliven the effect of the day-light on her wet skin.

△ **Reflectors for warmth**
A warm highlight, produced by a gold-colored reflector, helps to draw the figure out of the background by increasing the contrast between her and the dark walls behind.

Texture in Close-up

OFTEN, IT is far easier to see and appreciate the pictorial effects of texture in a photograph of a man or woman when you are not distracted by seeing the complete figure. Unless the skin texture is very prominent, this particular feature is all too easily overwhelmed by a flood of other recognition signals, not least among them the subject's sexuality.

Texture is the visual impression of the surface characteristics of the subject – the degree of roughness or smoothness – and it is this that gives us some notion of what the subject would feel like to our touch.

Lighting just a small part of the subject is far easier than lighting the complete figure, especially if you are working indoors with only a limited range of lights. Even outdoors, using sunlight as your source of illumination, you can change camera position and focal length to isolate just the area of the subject that reveals texture to best effect and so create a potentially rewarding photograph in a situation that perhaps is not ideal for general figure work.

◁ **Patterns of light and shade**
Angled lighting raking across the subject's body from the left of the camera position highlights the raised texture of his skin and these, in turn, cast tiny shadows into the adjacent hollows. It is this alternating highlight/ shadow pattern that creates the visual impression of texture.

▷ **Textural contrast**
The very fine-textured skin quality of the subject's back is evident in this photograph, something that is emphasized further when compared with the relatively coarse texture of the hands.

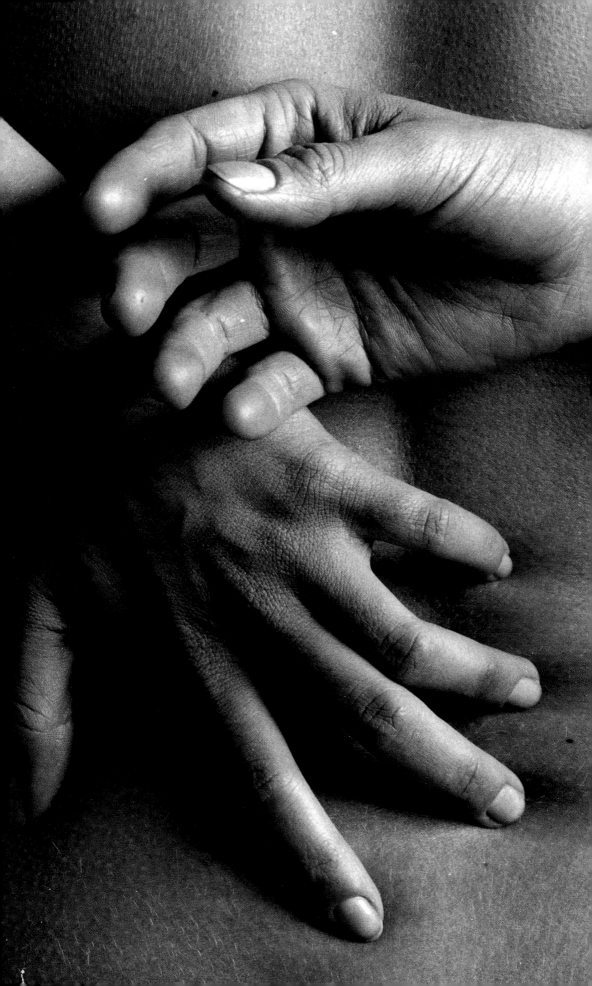

Unusual Framing

PHOTOGRAPHERS ACCUSTOMED to working with 35mm cameras (SLRs and compacts) or medium format models other than 6 x 6cm (2¼ x 2¼in) are used to having a vertical or horizontal framing option. To supplement these options, however, why not use the area within the frame to experiment with some more unusual and eye-catching ways of recording the figure?

With a camera producing a square image, for example, try turning the camera on its diagonal, if the subject is suitable, or frame subjects so that they run across the diagonal of the picture area when the camera is held normally. Unusual framing is also possible after you have taken the film: try turning the printing paper off center, for example, or heavily cropping the print.

▽ **Turning the camera**
To produce this image, a 6 x 6cm (2¼ x 2¼in) camera was turned diagonally. Make the camera movement obvious, however, since turning it just a little off center often looks like an error.

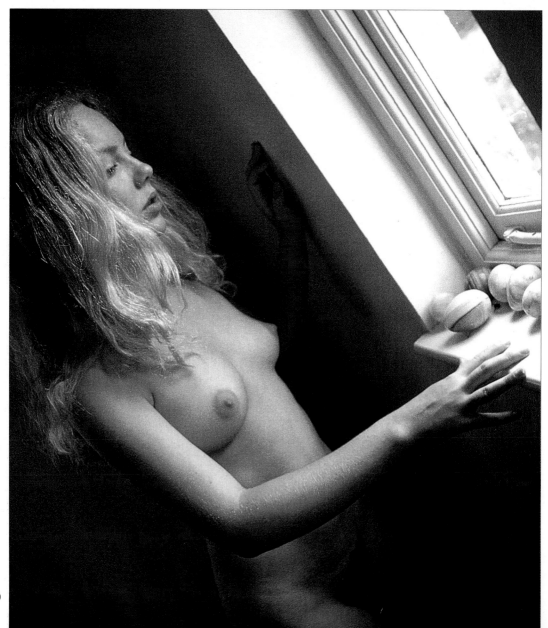

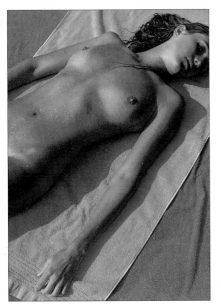

△ Diagonal framing

The traditional approach to photographing
this subject would have been to have stood
at the model's head or feet so that her body
ran across the picture frame either hori-
zontally or vertically. This diagonal framing,
however, is so unusual that it instantly catch-
es your attention, and it has the added bonus
of excluding completely the grassy areas
surrounding the towels. The inclusion of any
green at all would have seriously weakened
the composition.

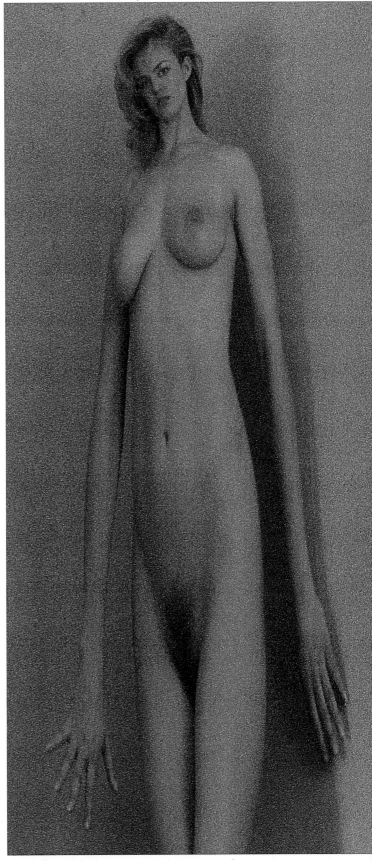

▷ Cropping for effect

The type of mirror found at fairgrounds was
used to create this bizarrely elongated reflec-
tion. To strengthen the impact of the subject
matter yet further, after processing the
photograph was trimmed to the left and right
of the figure to give a cropping so tight that
it could not conform to any known type of
camera format.

Obscuring the Subject

IN A DESIRE to vary the pace and character of their work, and as part of the development of an individual style and approach to their picture taking, photographers often feel compelled to seek out new, unusual, and imaginative ways of recording their subjects on film. One such way, shown here and overleaf, is to present only an impression of the subject's form rather than revealing the whole body to the camera. As you find in many subject areas of photography, and in other visual media as well, often it is what you cannot see clearly, what is obscured, that initially attracts your attention and then encourages you to linger and explore the entire image.

However, once the subject is partly obscured an uncertainty may be introduced in the mind of the viewer of the photograph, for if the camera cannot see the subject clearly, then perhaps the subject is also not aware of the camera's presence. It is this aspect of voyeurism that often brings with it a degree of titillation and excitement.

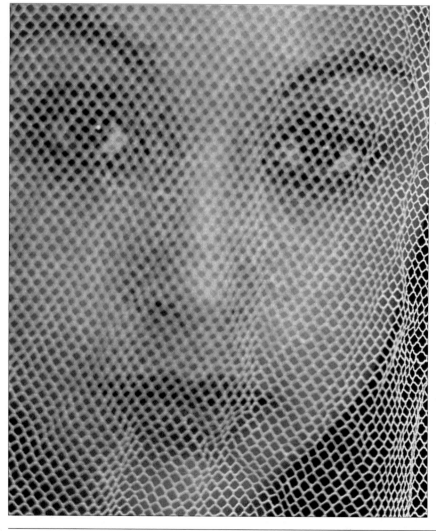

◁ **Veils to soften**
Although the subject's face can be readily seen, the veil softens the details of her expression, making us uncertain of her feelings about the camera's presence.

▷ **The power of imagination**
Although the textured glass in front of the model has robbed her figure of all details, leaving only an impressionistic outline, our imagination is such that we can see a wealth of detail.

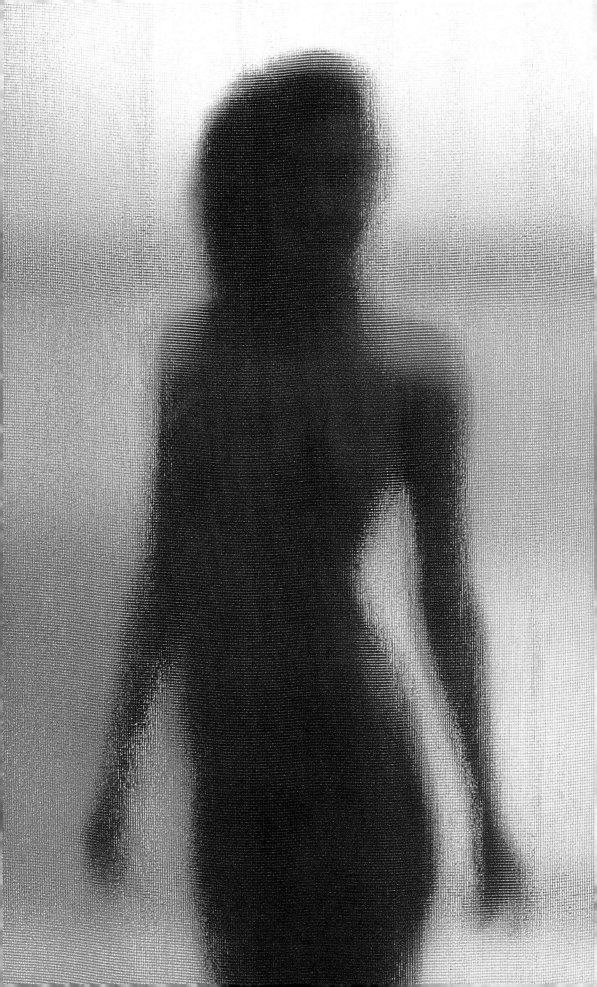

It is this concept that 'what the eye cannot see clearly, the imagination will readily supply' that underlies the popularity of this type of imagery. Yet, as a photographic style of presenting the nude, it probably came about as a result of society's strictures on the type of material that could legally be published, which in most instances prohibited blatant nudity. Interestingly, this same prohibition had not existed for hundreds of years for other art forms, such as painting and sculpture, which were at liberty to show all the physical attributes of the human body in an entirely realistic, and often sexually suggestive, fashion.

In this apparent inconsistency we can see the distinction that is drawn between photography and other art forms: a photograph is a frozen moment of reality, and those portrayed are not merely an artist's impression of the models, filtered and fine tuned by the imagination and then translated into paint or stone; they are, in fact, real people.

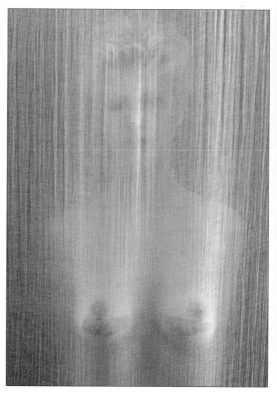

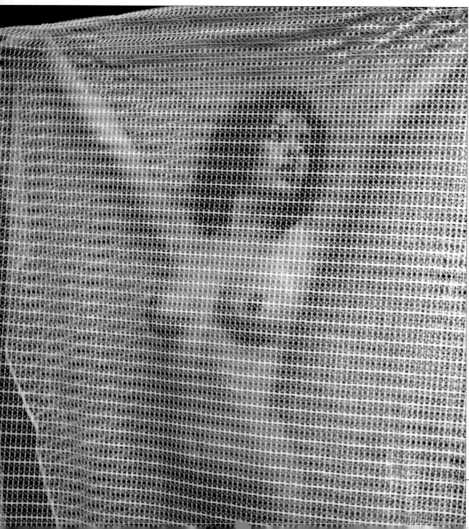

△ Semi-opaque
The plastic sheet behind which this model has been posed is almost opaque. It is only where her body actually comes into contact with the plastic that the material takes on a new character, becoming more translucent in nature.

◁ Shape changes
In the absence of color other factors become more pronounced – here the light-gray tone running underneath the model's arms and diagonally across her body, forming an elongated cross.

▷ Glamor pose
Partly obscured by condensation on the inside of the window, this model is seen in a typical glamor pose.

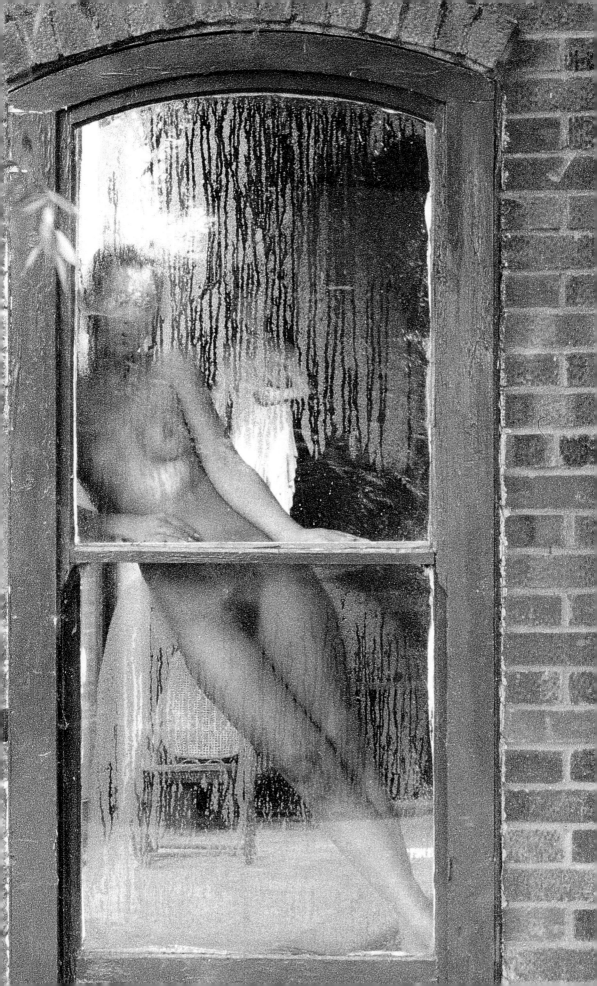

Depth of Field

A s well as controlling exposure, the aperture also helps to determine a picture's 'depth of field'. This is the area both in front of and behind the point of focus that is also acceptably sharp. Small apertures produce a greater depth of field than do large ones; short focal length lenses produce a greater depth of field than do long focal length lenses at any given aperture; and depth of field also increases at any given aperture the further away from the camera you focus the lens. Knowing how to manipulate depth of field means that you can control the emphasis given to any part of a photograph.

Sometimes, though, you have to compromise. If you want an extensive depth of field and select a small aperture such as f22, you may have to choose a shutter speed to compensate that is so slow you need to use a tripod. If you don't have one, there may be no option other than to set a larger aperture that allows you to use a faster shutter speed. Conversely, to limit depth of field, you may select a large aperture such as f1.2 and then not have a shutter speed fast enough to avoid overexposure.

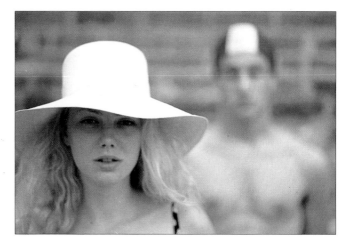

△ **Large aperture, near focus**
Using a 90mm lens at f2.8 on a 35mm camera, depth of field was so narrow that when the lens was focused on the near figure, the far figure and wall were completely blurred.

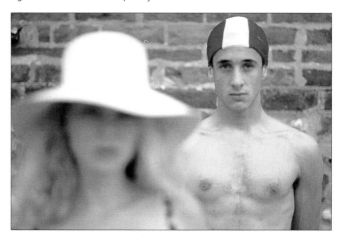

△ **Large aperture, far focus**
For this picture, the lens and aperture were the same as those used for the first image, but this time focus was switched to favor the rear figure. As a result, the foreground figure has been reduced to a soft blur.

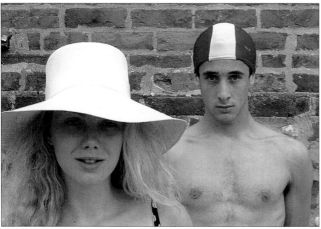

◁ **Small aperture**
In order to show both figures sharply focused, the lens was reset to an aperture of f22 to increase the depth of field. To compensate for exposure, the shutter speed was changed from $\frac{1}{500}$ second to $\frac{1}{15}$ second.

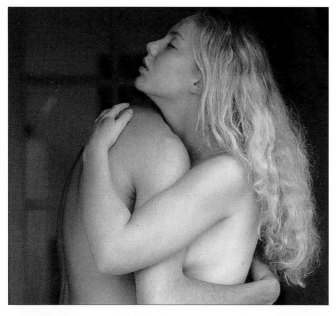

◁ Isolating your subjects

Use large apertures when you want to show your main subject or subjects in isolation from their surroundings. Although the background is dark in this photograph, an aperture of f4 on an 80mm telephoto lens made sure that what can be seen beyond the figures is sufficiently soft not to intrude.

▽ Showing the setting

Use small apertures when it is important that the setting as well as the main subject are sharply focused. This attractive lakeside location gives a lot of texture to the content of the photograph, and so an aperture of f16 on a 35mm wide-angle lens was used. As a result, everything from the immediate foreground to the far distance is acceptably sharp.

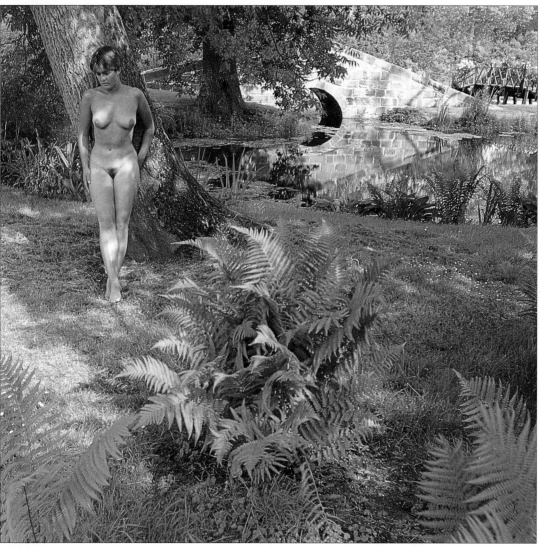

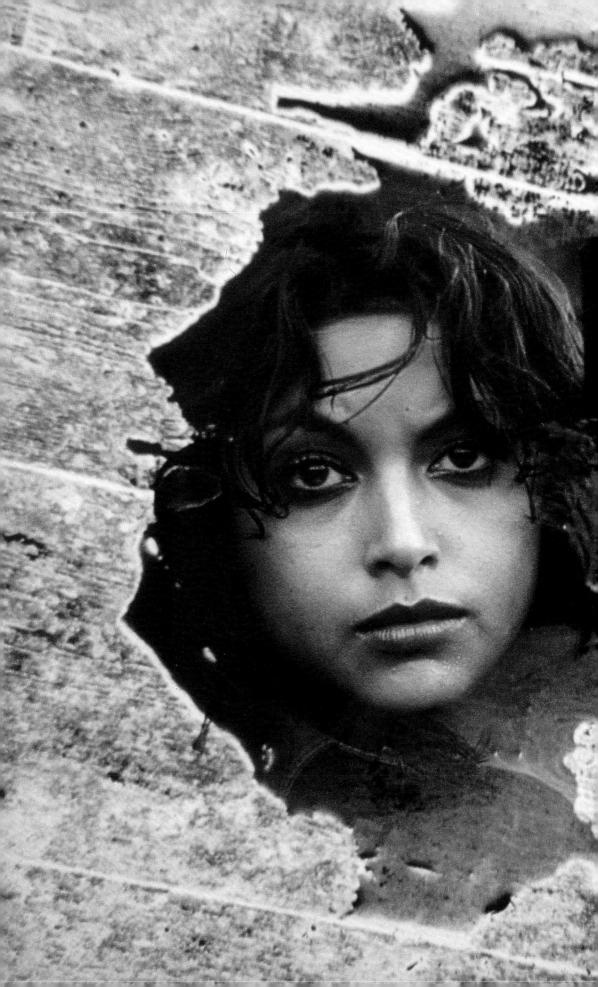

Special Effects

T HE RANGE OF special effects available to the photographer is wide and very varied. Special effects can be as simple as exaggerating the distinctive perspective characteristics of wide-angle and telephoto lenses, for example, or they can involve manipulating the print in the darkroom after the film has been processed, or combining film and light sources to produce strange-looking color casts. Now that low-cost digital scanning of photographic originals is so readily available, however, the newest innovation for the experimental photographer, is the computer.

Projected Images

A SIMPLE technique for producing bizarre juxtaposition of subject matter involves nothing more than overlaying your subject with a projected image and then photographing the result. Alternatively, you can try projecting a slide image of your subject on to, say, a piece of furniture or paneled door. As long as the object has a variety of surfaces at different angles to the projected image, interesting effects are likely to result. However, only use the light from the projector to shoot with – any additional light will weaken the image.

When using a person or object as the 'screen' for an image, the degree of sharpness of the projection depends on how far the subject is from the background and on where you decide to focus the projector. Even if you focus the projected image on a subject who may be only a few inches away from a background wall, those parts of the image spilling on to the wall may be noticeably less sharp. And if the depth of field of the projected slide is not extensive, you may not be able to hold sharp focus over all of the contours of the subject's body.

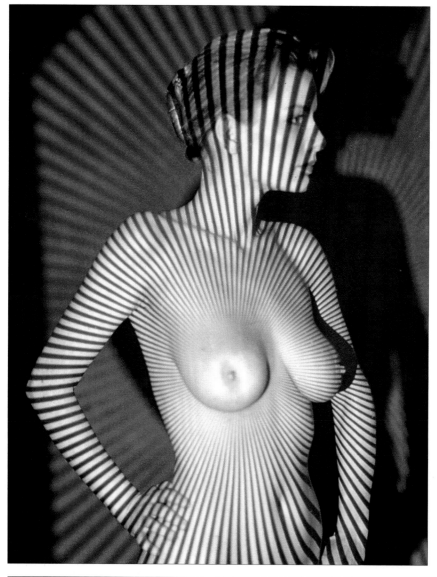

◁ **Shape-flattening pattern**
Normally when projecting a regular pattern on to a subject you tend to suppress any underlying shape. In this example, however, the pattern on the wall behind is less sharp, and the subject's shadow is also visible, and both of these features are indicators of depth and distance.

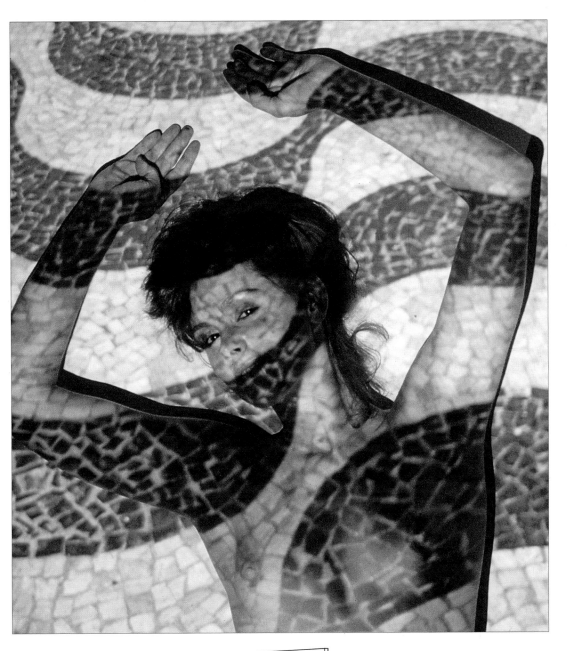

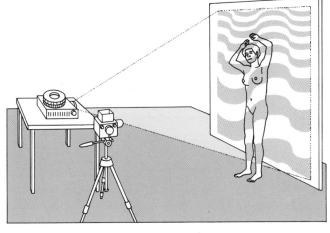

◁ △ **The set-up**
In order to make the image above, the model was positioned against a white-painted studio flat so that her body was in contact with its surface. In this way, the projected image would, as far as was possible, appear sharp on both her body and the background. The projector was then switched on and aligned with the model so that the blue and white bands of color on the slide made the most interesting pattern. The model was then photographed on daylight-balanced film using an aperture of f11 and a shutter speed of ⅟₃₀ second.

Wide-angle Lens Effects

ALL CATEGORIES of lens, including wide-angles, produce a particular type of "look", or perspective, when used to take pictures of people or scenes.

Extreme wide-angle lens, sometimes called fish-eyes, display a type of effect known as barrel distortion, in which vertical lines, especially those near the edges of the frame, are dramatically bowed.

Less extreme optics, such as 19mm and 28mm wide-angles, are often used for straight photography when it is important to show a well-separated foreground, middle ground, and background, or a large expanse of sky that seems to stretch over and behind the camera. If used close up to a subject, however, they can also produce strange shape distortions.

▽ **Big skies**
A 19mm wide-angle was used to take this image. Note how well the subject planes are separated and how immense the sky above the model looks. Depth of field can be so extensive with these lenses that focusing is not critically important.

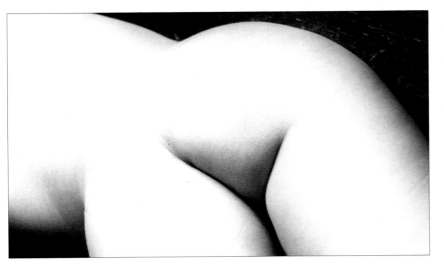

◁ **Shape distortion**
The close-focusing ability of a 28mm wide-angle has been put to good use here. The parts of the subject closest to the lens have been enlarged in relation to the rest of the figure. This, combined with the severe cropping and slight overexposure, has produced an alabaster-like abstract composition.

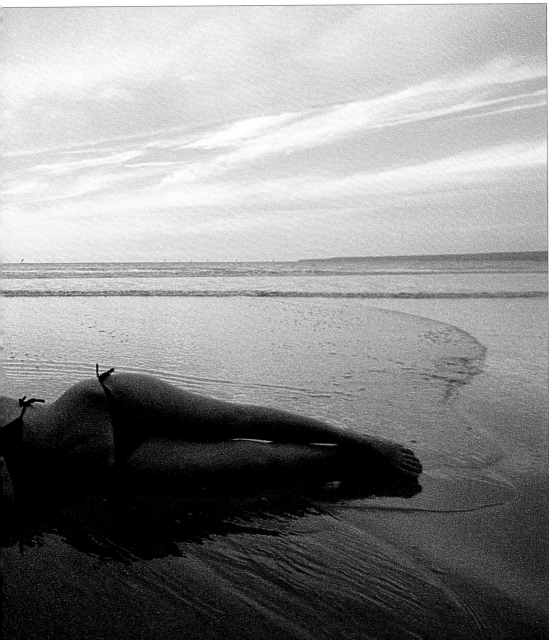

Telephoto Lens Effects

WHEREAS WIDE-ANGLE lenses tend to open out perspective in photographs (*see pp. 78–9 and 122–3*), telephoto lenses have the opposite effect – they close up the image planes to produce a squashed, sometimes claustrophobic, look.

Moderate telephoto lenses, such as those in the 80–90mm range on a 35mm camera, are often known as portrait lenses because they allow you to fill the frame with a person's head and shoulders without any obvious distortion and without having to approach too close to the subject. More extreme focal length lenses,

however, 150mm and longer, noticeably enlarge the background elements in relation to the foreground ones. This can have the effect of making a subject's face look oddly flat as the eyes, cheeks, lips, and chin are enlarged in relation to the nose.

Think of a telephoto lens as being like a telescope, which, as well as having a magnifying effect on anything it focuses on, also has a very limited angle of view. This characteristic comes into its own when you need to exclude extraneous clutter in a scene and concentrate attention on the subject alone.

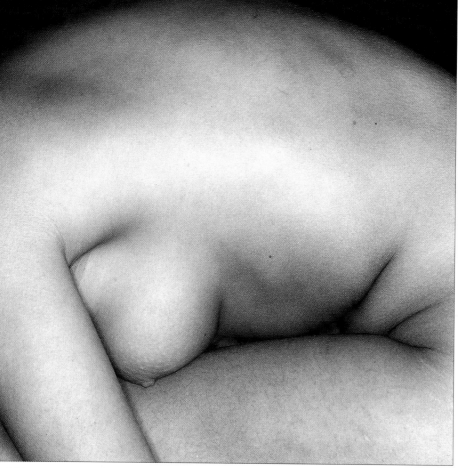

◁ **Cropping in the camera**
It is always best to make cropping decisions before pressing the shutter. This way, you will be able to make full-frame enlargements without running the risk of over-enlarging the negative. Here, I have excluded the head, buttocks, and lower legs of the model by taking advantage of the limited angle of view of a 135mm lens.

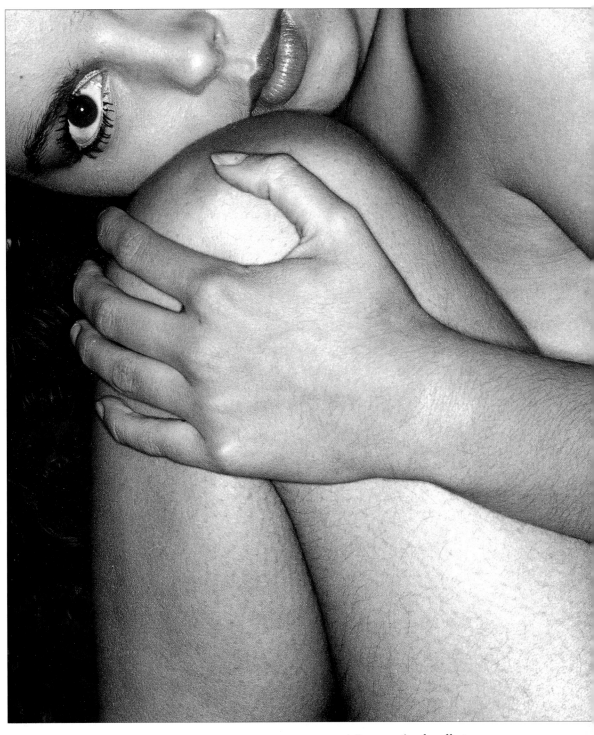

△ **Exaggerating for effect**
In this picture, I have accentuated the
sometimes claustrophobic perspective of a
long telephoto lens (350mm) by framing
the subject so that she appears to be con-
fined in a space far too small for her body.
Her single visible eye, intense and staring
directly into the lens, looks over-large in
relation to her nose.

Body Painting

Unless you are particularly skilled with a paintbrush, then it is probably a good idea to hire the services of a professional body painter to prepare your models before the session starts. Make sure you allow sufficient time, since it takes between 60 and 90 minutes to paint a model from top to toe, depending on the number of colors being used and the type of design that is required. A design with many overlapping colors, for example, takes longer to create because of the drying time involved before the next color can be applied.

Discuss with the body painter the type of effect you want to achieve. You will probably need a starting point, a concept of some type around which the painted pattern will be developed. It is vital, therefore, that you show the painter the background the model will be seen against so that the right colors can be selected.

Body paints are available from art supply stores and children's party shops. Make sure that the paints conform with all relevant safety requirements and that you apply a good-quality barrier cream to the model's skin in advance.

HINTS AND TIPS
■ It can be dangerous to paint all of the model, leaving no area at all where the skin can breathe. If you are uncertain on this point, seek professional advice before starting.
■ Always use specially prepared body paints to minimize the risk of an allergic reaction.

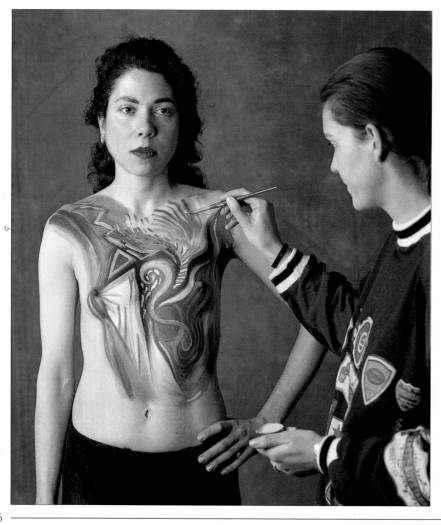

◁ **Preparation**
After discussing with the artist the types of colors and style of decoration required, the transformation can begin. The photographs of the end results will be looked at critically, so you have to allow plenty of time if you want to see a good, neat job.

▷ **Plain background**
A very colorful background and a brightly painted model may simply be an overpowering image, appearing visually cluttered and confused. A neutral, unpatterned background often has far more impact.

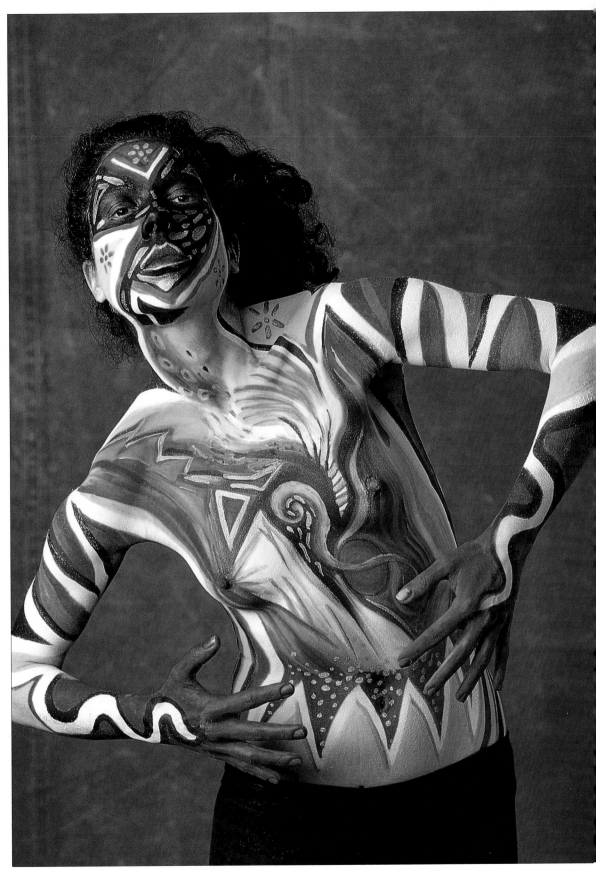

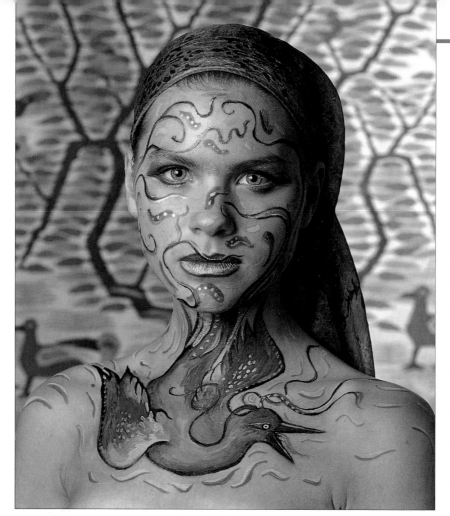

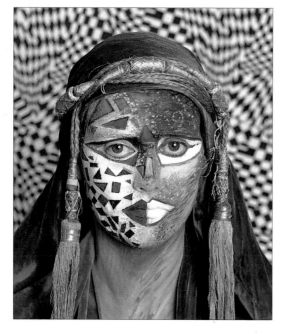

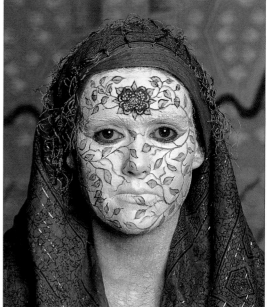

◁ ▽ **Patterned backgrounds**
In this set of three very different body-painting styles, you can see that each has been carefully designed to coordinate with the patterned backgrounds. In the first photograph (*left*), the theme of birds has been carried through from the model to the background. In the other two pictures (*below left* and *right*) it is color and pattern that help to create a unity between fore- and background.

▷ **Lighting style**
Undiffused flash lighting was used to light the model here. However, to prevent unwanted reflections from her painted face, barn-doors were used to reduce illumination locally.

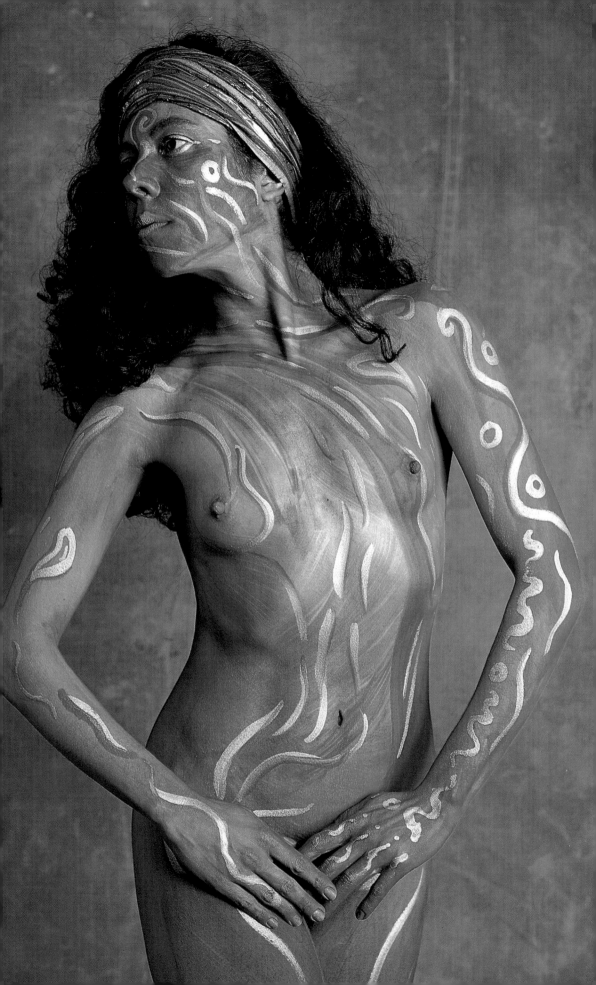

Mismatched Lighting

WHEN BUYING color transparency film (and color negative film as well when results are very critical), you need to specify the type of lighting the film will be exposed to or color casts may be noticeable after the film is processed.

Daylight-balanced film, as its name implies, is intended to be exposed under the whole range of natural light conditions without producing color casts. You will find, however, that different brands of film have different color characteristics, with some tending to produce stronger blues, for example, and others stronger greens. Daylight-balanced film can also be used with all types of electronic flash – studio as well as camera-mounted types – since it has the same 'color temperature' as daylight.

Tungsten-balanced slide film is intended to be exposed under studio tungsten or some types of ordinary domestic tungsten lighting. There are a few brands of tungsten-balanced print film available. This is not widely used, however, since standard color print film can almost always be satisfactorily corrected for color balance during the printing stage.

▷ Mismatching for effect

Although photographers usually strive to ensure that they use the appropriately balanced film for the lighting they will be working with, interesting effects can result when you purposely mismatch film and light source. In the example here, tungsten-balanced slide film was used outdoors toward dusk. The strong blue cast is evident because this film is designed to compensate for the fact that tungsten light is deficient in the blue part of the spectrum. The figure appears correctly balanced, however, because she was lit separately with a tungsten floodlight.

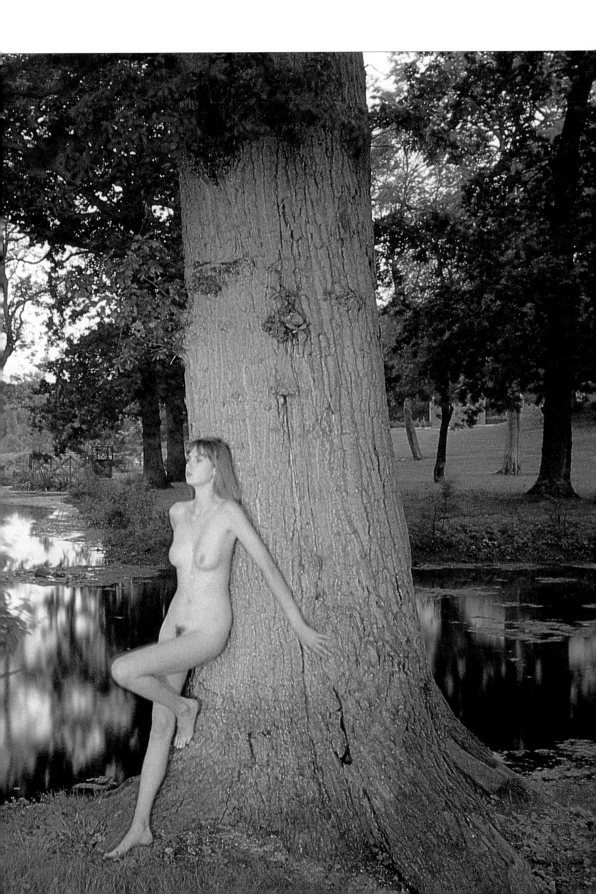

Paper Grades

Printing paper used to produce black and white images is available in a range of contrast grades. Low-contrast, or 'soft', grade 0 or 1 papers reproduce the greatest range of intermediate tones (or shades of gray) between black and white; high-contrast, or 'hard', grade 6 papers are capable of producing whiter whites and more dense blacks than softer grades, but they have an abbreviated tonal range in between.

Paper grades are selected to suit the contrast range of the negative being printed. For example, a contrasty negative would be printed on a soft paper grade to make the most of the original's tonal range. However, if you team contrasty negatives with hard paper, strikingly graphic images may result.

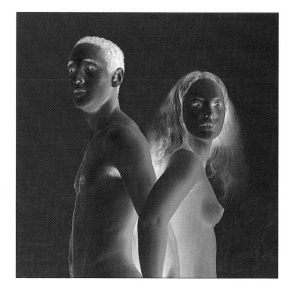

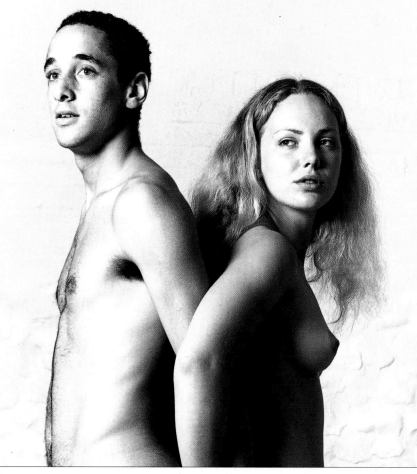

△ **The negative**
Interpreting a negative before printing is initially difficult, since all the tones are reversed: clear areas on the negative print as black, while dense areas on the negative print as white (or light gray). You can see from this negative that there are areas of dense and open tones that will produce good whites and blacks, but there are not many intermediate tones. This negative, therefore, would be considered to be contrasty.

◁ **Normal/grade 3**
As a control print, the contrasty negative above was first printed on a normal/grade 3 paper. Some problems are immediately obvious, especially in the shadowy parts of the woman's face and body, which have gone a little 'muddy'.

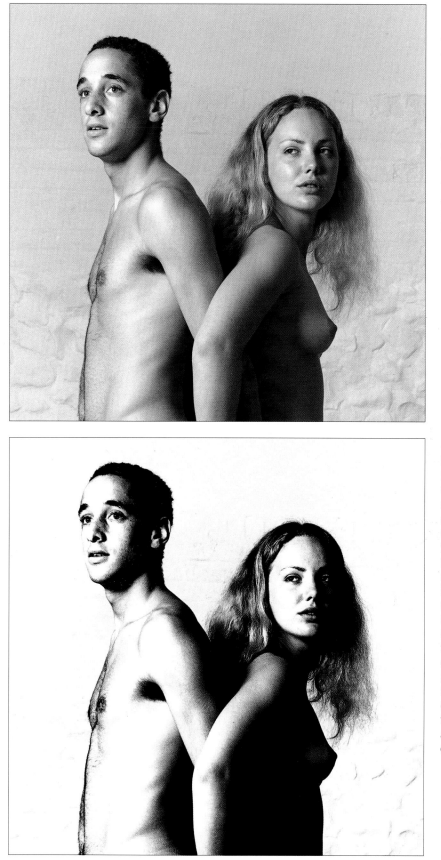

◁ **Soft/grade 0 or 1**
In order to produce a full-toned image, teaming a contrasty negative with a soft grade of printing paper gives the best results. The skin tones of both the subjects are now well defined and their form is also more apparent. More tonal information is also present in the rough-plastered wall behind them.

◁ **Hard/grade 6**
Usually, grade 6 printing papers are used when you are trying to separate out the tones of an extremely low-contrast negative. Such a negative would not produce a clean white or a punchy black if printed on a softer paper grade. However, in this example, most of the intermediate grays of the negative have been omitted and the image has been dramatically transformed as a result, and now consists of either black or white.

Darkroom Trickery

I F YOU have your own dark-
room, or access to one
through a local photographic
club, then the original film image
recorded in the camera could sim-
ply be the starting point for an
extensive range of effects.

Due to the complicating factor
of color balance when exposing
color printing paper, and the vari-
ability of this color balance every

time paper exposure times vary,
black and white film originals
and printing papers are far easier
to work with. Black and white
printing paper and processing
chemicals are also less expensive
than their color equivalents and
processing times much quicker.

Two of the most common
darkroom manipulations involve
giving specific parts of the

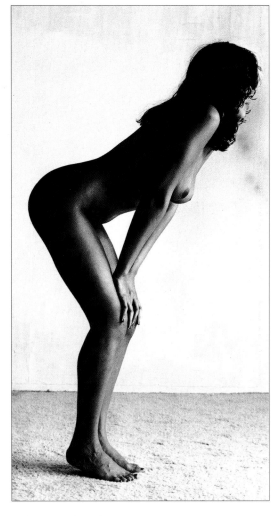

△ **The 'straight' print**
In this version of the image, no manipulation
took place. All of the printing paper has
received the same exposure and all of the
subject can be clearly seen.

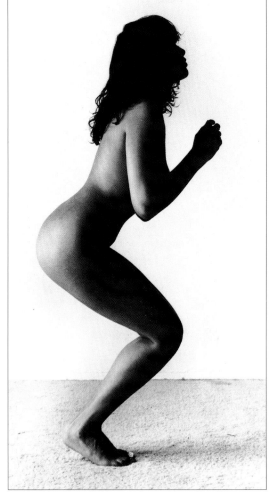

△ **Burning in and dodging**
By dodging with a piece of opaque card, the
model's left leg has been made to disappear
(the carpet and background were later
retouched). Her face and arm were also
burned in to turn them a featureless black.

printing paper either more (known as burning in) or less (dodging) exposure to a negative under the enlarger in order to selectively darken or lighten those areas of the print.

In most situations, the object of burning in and dodging is to adjust the image's tonal balance so that the end result looks completely natural – simply a better balanced print overall. However, taken to extremes, these techniques can be used to change completely the mood of a photograph or, in fact, its content.

When you want to prevent some part of the original film image printing altogether, as in the vignetted image on the right, where the background has been removed, you need to shield the corresponding part of the printing paper from the enlarger's light throughout the entire exposure.

△ Making a vignette
Cut out an appropriate-sized aperture in a piece of card, through which the subject can print, and hold the card under the enlarger so that its shadow is cast over all of the remaining printing paper.

▷ Removing a background
The object of creating this vignetted image was to remove the background tone (see left). Keep the card used to vignette the image (see above) slightly on the move all the time to prevent a clearly defined band of tone.

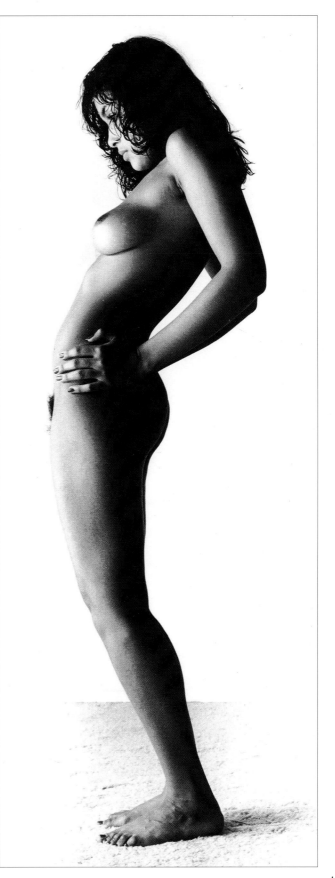

Computer Imagery

THE READY availability of powerful yet affordable computers, as well as such important peripheral devices as scanners, has given the photographer unprecedented control over the appearance of the final camera image. Any number of images can be seamlessly blended together, specific subject elements removed or added in, countless filter effects applied, or individual colors altered. And when you are completely happy with what you see on your color monitor, the new image can be output directly on to paper via a color printer or, alternatively, on to a new piece of film for printing or projecting in the traditional way.

The starting point for all of this need not even be a negative, slide or photographic print – illustrations and artwork from books and magazines can be used just as well. Once the original has been digitally scanned, the possibilities are endless.

▽ ▷ **Montage**
To create the montage opposite, the two images below were first scanned into the computer. The picture of the woman was reduced to 50 per cent of its original content of yellow, magenta, cyan, and black components (to reduce its opacity) and then overlayed on the image of tree bark.

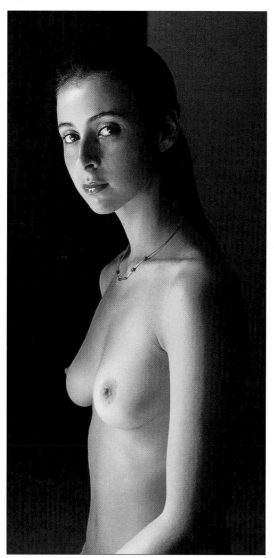

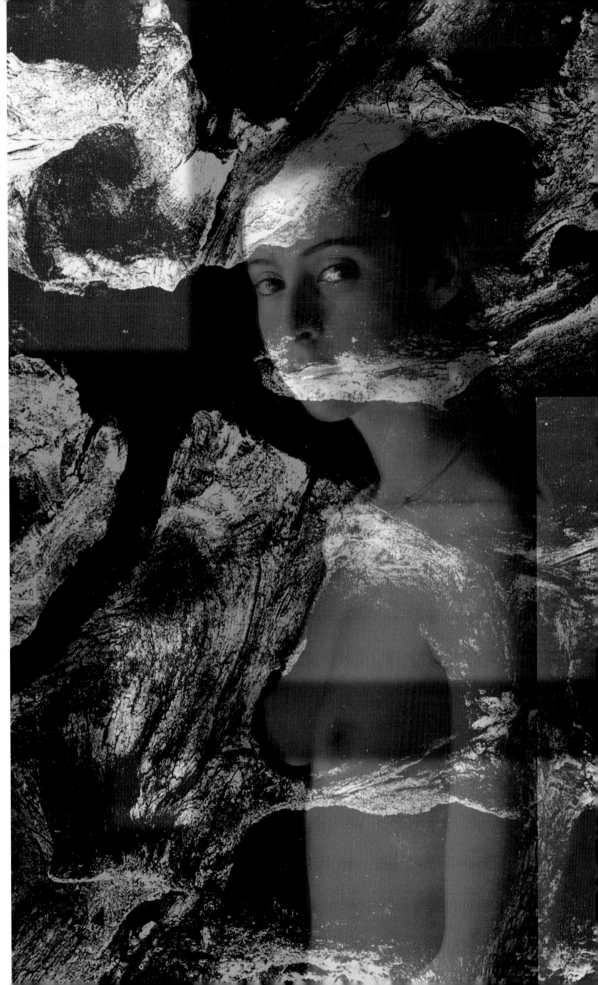

◁ **First manipulation**
The original of this image was a color print. After scanning it into the computer, its color content was altered by increasing the cyan and magenta components while decreasing the black. This first stage of the manipulation was designed to maintain all of the original's mid-tone values.

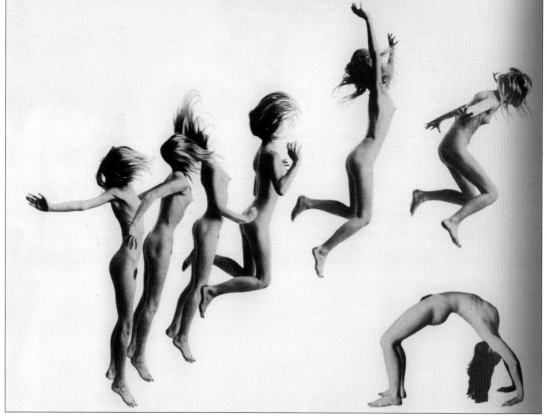

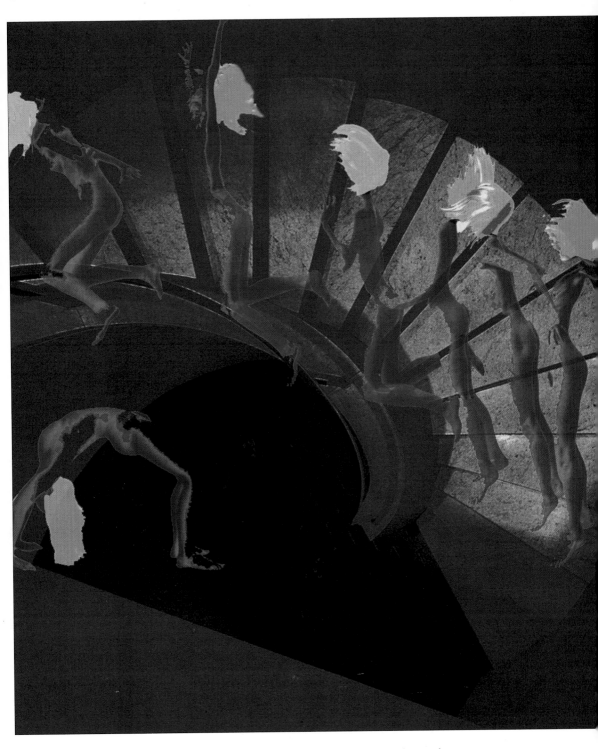

◁ **Second manipulation**
Although this picture looks like it has already undergone computer manipulation, it is in fact a multiple print produced in the tradition-al way in a darkroom. However, as an initial computer treatment of this component of the final image, the background had to be com-pletely deleted. Although it appears white, there is always some color present.

△ **Composite result**
With the background to the jumping figures deleted, they were then laterally reversed so that, when combined with the stairs, they look as if they are jumping up the spiral. The figures were then all reduced by 30 per cent to make them less opaque, thus allowing the base image to show through. Finally, the hair of each figure was 'painted' yellow.

△ First original
If they are fitted with the appropriate adaptor,
digital scanners can cope with a color
transparency, like the one shown here, as
easily as a paper print. You can see that in
the manipulated version on the right, the
figure has been rotated through 90°.

◁ Second original
This black and white
print has been used
as the background
component for the
manipulated version
above. As a first step,
however, all of the
tone showing between
the woman's body and
arms had to be delet-
ed, leaving her as a
'cut-out' figure.

△ **Watery world**
As well as reorientating the underwater swimmer, all of the background on that transparency was deleted. But rather than discarding it, it was saved for later use. The yellow, magenta, cyan, and black color components making up the figure of the swimmer were not reduced and, as you can see, the background torso does not show through wherever the swimmer can be seen. Finally, the background that had been deleted from the original transparency was reduced in color strength by 70 per cent, resized to fit the new image area, and pasted back into position.

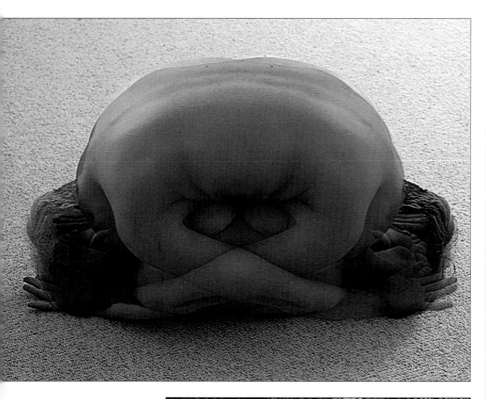

△ Modern life

By copying the picture of the original crouching figure, reducing the copy in strength by 25 per cent, deleting the background, flipping it though 180°, and then pasting it back on top of the original, an image personifying the stresses of modern-day life seems to have emerged.

▷ Copy and paste

In this version of the image from p.59, the tree trunk emerging from between the model's legs was deleted, leaving the canopy of leaves mysteriously suspended in thin air. Selected areas of background were then copied and pasted back to fill the gap created by the missing trunk.

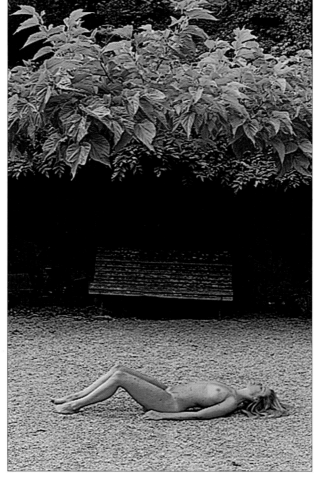

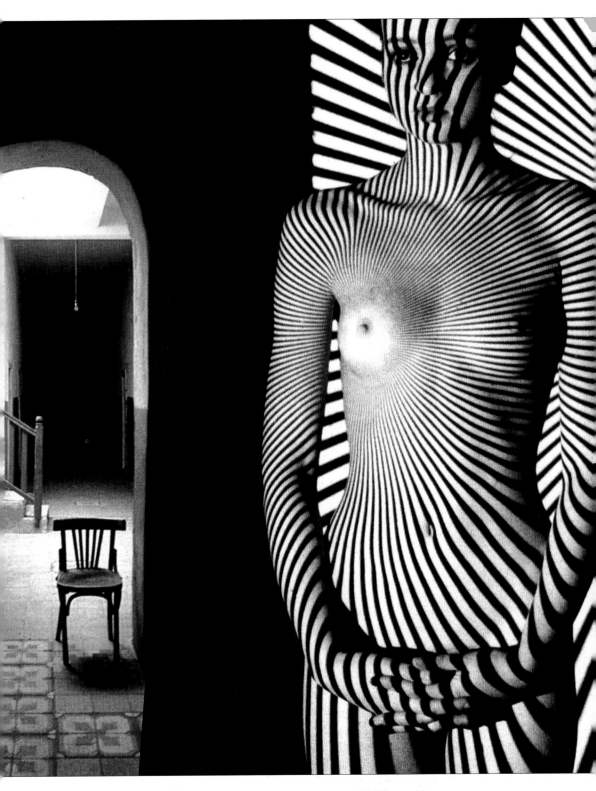

△ **Multilayered imagery**
This picture was created by combining three transparencies. The first is the scene through the archway; the second is of the darkened hall and chair; and the third is of the woman overlayed with a projected pattern.

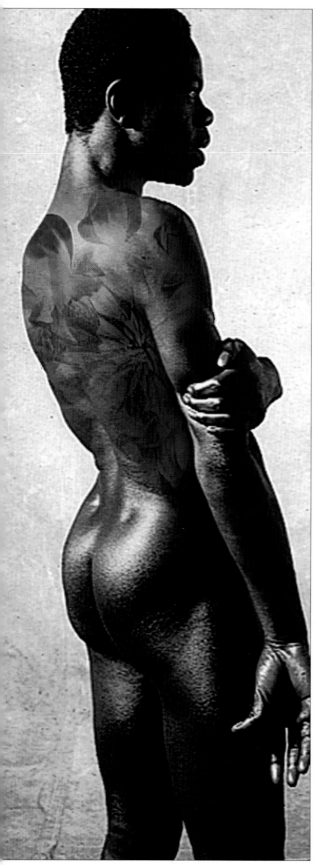

◁ Floral tattoo

There is no need to go through the pain of a full-body tattooing process when any found image can be scanned, reduced in strength (to increase its transparency), and then pasted, or cloned, into position.

△ Zoom effects

This computer manip-ulation perfectly mimics the type of effect you can achieve by zooming a camera lens while the shutter is open and the film is being exposed. The degree of zoom and streakiness can be selected from a pull-down menu of options.

▷ Melting away

To make it appear as if the figure is melting into the background, the lower part of the model was deleted. Areas of the back-ground were then copied and pasted into the hole created, overlapping the figure slightly to prevent a clear demarcation.

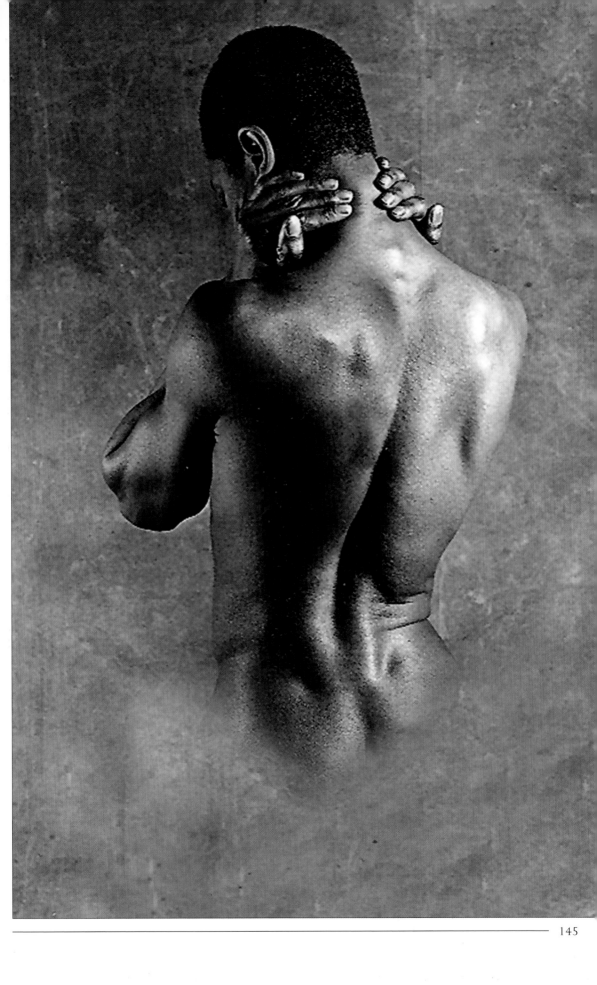

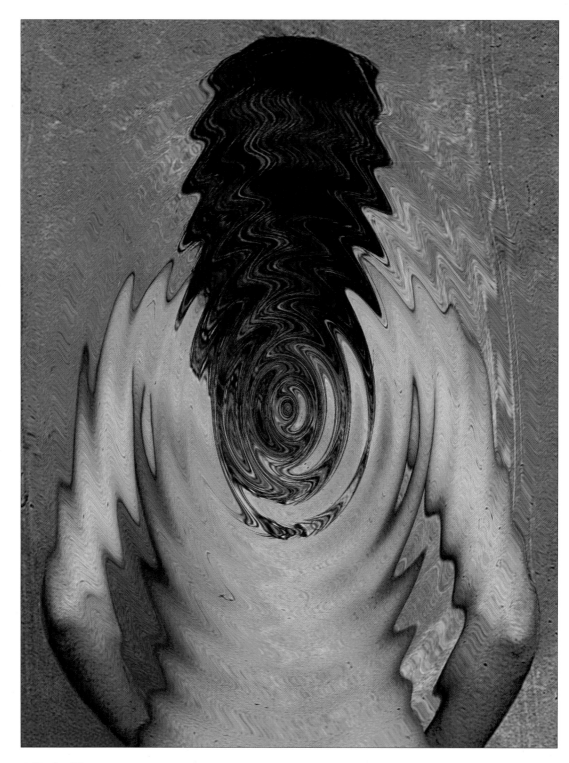

△ **Ripples filter**
The computer programs used for these types
of manipulations often have extensive libraries
of 'filters' (preset effects), such as that above
and those opposite, which you can apply to
any scanned image. You have the option with
the ripples filter of determining where the rip-
ples emanate and the number of ridges.

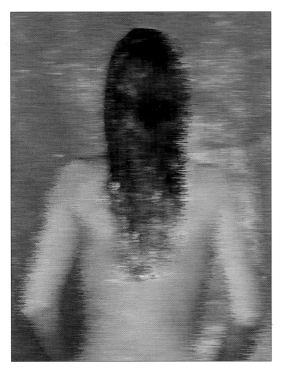

△ **Wind filter**
You can alter the degree and appearance of
the windswept effect and also the direction
of the distortion created.

△ **Pixelate filter**
This effect is like the half-tone screens used in
book and magazine printing processes. The
more pixels used, the finer the image.

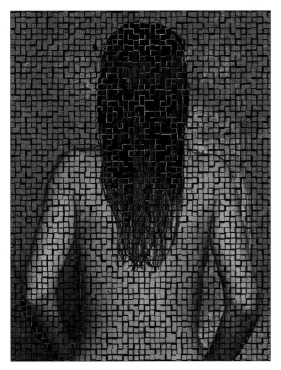

△ **Tile filter**
This filter gives you the option of specifying
the number of tiles used, their degree of off-
set, and the background color between them.

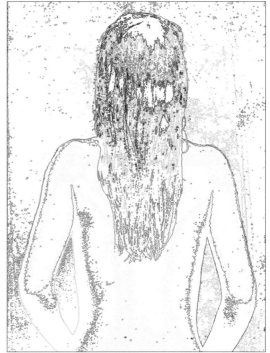

△ **Trace contour filter**
Here you can pick up on the different color
densities present in the original image and
convert them into a false-color contour map.

Technical Appendix

CAMERAS

The two types of camera used most often by serious photographers are 35mm single lens reflex (SLR) cameras and medium format models. Generally, SLRs have certain advantages over the medium format when working out on location or for candid photography, while medium format models are often preferred in the studio environment.

35MM SLR CAMERAS

The design of this camera format, and especially of the better-quality lenses now available, has reached a point where (except in cases when extremely critical results are required or very big enlargements are to be made) picture results are truly excellent. And since SLRs are popular with both amateurs and professionals alike, the cameras and lenses are made in sufficient volumes to be extremely competitively priced.

The popularity of this format is due largely to three important features. First, SLRs are relatively lightweight and easy to use when compared with medium format cameras. Second, because of the type of optical system used inside the camera, the image you see in the viewfinder is exactly that seen by the lens, no matter which lens is in place. And, third, the design of the camera allows for interchangeable lenses to be used.

Again due to the popularity of the 35mm camera – SLRs and compacts (*see opposite*), which both use the same film – there is a greater range of film types made for this format than for any other. Film costs, too, per frame are much less as are processing and printing prices.

MEDIUM FORMAT CAMERAS

These cameras, like their 35mm counterparts, accept interchangeable lenses and have a viewfinder system that always shows the view seen by the lens. However, they are generally far heavier than 35mm cameras and are not nearly as easy to use.

The huge advantage they have over 35mm is their film size. Being much larger, resulting prints and slides are potentially finer grained and capable of being printed or projected to a greater size without loss of image quality.

△ **35mm SLR**
Most good-quality SLRs can be used in any of a range of automatic modes or switched to manual when required. A wide range of lenses can be attached to the body and film choice is extensive.

▽ **Medium format**
This model is the smallest of its format although its film size is still larger than 35mm. Their size and weight make them more suitable for studio work.

OTHER 35MM CAMERAS

The most popular camera type used by amateur photographers is the 35mm compact, or point and shoot. Top models have good-quality lenses, sophisticated autoexposure systems, autofocusing, and all models use ordinary 35mm film. However, for serious photography the drawback is that the lens is fixed – either a single, slight wide-angle or a zoom lens covering a limited range of focal lengths. As well, to keep the weight and size down the simple viewfinder system employed does not allow you to see precisely the view taken in by the lens.

Catering for those who want the precision of an SLR but don't want to carry a range of different lenses, the 35mm camera below right has all of the features of a normal SLR as well as a fixed zoom lens covering an extensive range of focal lengths.

▽ **Fixed lens SLR**
This camera type offers all of the features expected of a good-quality 35mm SLR, except that it has a fixed zoom lens. If necessary, an adaptor can be fitted to the front of the lens to extend its coverage.

△ **Compacts**
Although good-quality pictures are possible using a point-and-shoot camera, its basic viewing system and single fixed lens are serious drawbacks for serious photography.

LENSES

Optics for interchangeable-lens cameras range from extreme wide-angles, or fisheyes, that produce a circular 360° view, to powerful telephotos capable of taking quite detailed pictures of the moon. These extreme focal lengths have only limited applications for everyday photography, but the range in between gives 35mm SLR and medium format camera users unparalleled flexibility.

As well as an extensive range of fixed focal length lenses, there are also zoom lenses. Although lens quality (the amount of subject detail the lens will resolve) may be slightly less with some zooms, the advantage of having all the focal lengths between, say, 28mm and 70mm, or 70mm and 210mm, in a single lens is a powerful argument in their favor.

As well as focal length and quality, another factor to consider is lens 'speed'. This refers to a lens's largest, or maximum, aperture. The larger this is – say, f1.4 on a standard lens – the faster the lens is considered to be. A fast lens is desirable because it gives you a greater range of exposure options (aperture and shutter speed combinations) in low light. Fast lenses are more expensive.

Typical lens apertures (f stops)

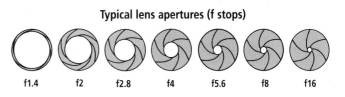

| f1.4 | f2 | f2.8 | f4 | f5.6 | f8 | f16 |

△ **Lens apertures**
Also known as f stops or f numbers, lens apertures help to control exposure and depth of field. Large f numbers denote a small aperture, while small f numbers denote a large one. Each time you open the lens up by one f number you double the amount of light reaching the film.

LIGHTING

There will be many occasions when you need to use some form of artificial illumination. This could be because available light levels are too low either for correct exposure or to allow you to use your preferred shutter speed/ aperture combination, or because the available light is too flat or too contrasty. Indoor photography, either in a studio or in a room in your home, often benefits from additional lighting to boost, or supersede altogether, any window light that may be available.

ACCESSORY FLASH

The most convenient form of artificial light is that from an electronic accessory flash unit, or flashgun. Many point-and-shoot compacts, and more and more SLRs, have small flash units built in to the front or top of the camera body. Although convenient, these units are not very powerful, cannot usually be angled to provide indirect, or bounced, illumination and they are prone to 'red-eye', in which the whites of the eyes of subjects appear blood red in color.

More flexible types of flashgun are those that fit into the hot shoe on top of an SLR or are mounted on a side bracket attached to the base of the camera. As well as being more powerful than most built-in types, their lighting head can also, on all but the most basic models, be swiveled and tilted to bounce the light off a wall or ceiling. This greatly increases the range of lighting effects you can create with your flashgun.

Sophisticated 'dedicated' flashguns have sensors that monitor the amount of light reflecting back from the subject and reaching the film, and automatically ensure correct flash exposure for the lens aperture you have set.

All electronic flash is compatible with daylight.

STUDIO LIGHTING

When large areas indoors have to be evenly illuminated, an accessory flashgun is inadequate, especially if its light is not being

◁ **Side-mounted accessory flash**
This type of flashgun, sometimes referred to as a hammer-head flash, attaches to the camera via a bracket screwed into the tripod bush on the camera's baseplate. The head swivels and tilts for a range of lighting effects. The computer-controlled light sensor on this model is a separate unit, which you can see in the camera's hot-shoe. The connecting cable controls the flash's light output, as well as triggering the flash to fire when the shutter operates.

△ **Basic studio flash head**
This mains-powered studio flash has almost instantaneous recycling times between flashes and the reflector surrounding the lighting tube can be swapped for other shapes.

△ **Spotlight**
When a very confined beam of light is required, a spotlight is ideal. The lens at the front of the light can be varied to control the spread of illumination.

supplemented by daylight. In these circumstances, you need to use much larger flash units, known as studio flash. These work essentially on the same principles as accessory flash, producing large amounts of short-duration light. Each flash head has its own lighting stand or mounting bracket and is either plugged directly into the mains or into a power control unit. The light output from each head is variable, which increases lighting flexibility, and a large range of accessories – such as softboxes, snoots, reflectors, barndoors, and scrims – is available to vary lighting quality.

Continuous-light studio tungsten units can also be used. These are less expensive to buy, but the high-output bulbs are a continuous expense, since they have a very short working life, and they also produce enough heat to be uncomfortable. Tungsten light is not compatible with daylight.

TRIPODS

For best results, a rock-steady camera is essential, especially if large-scale enlargements are to be made. If your shutter speed is fast enough, and the camera and lens

combination is not too heavy, then it is safe to hand-hold the camera while shooting. However, a tripod guarantees shake-free pictures, and it also allows you to mount the camera in the correct position while you adjust lights or talk to your models. Lightweight, yet sturdy, models are available for location shooting.

△ **Lighting kit**
This lighting kit is suitable for most studio lighting tasks. The three lighting heads, softbox, snoot, and lighting stands all fit into the carrying case shown and can be easily transported to any required location.

Glossary

A

AE
A commonly used abbreviation for automatic exposure – in which the camera determines the aperture and shutter speed combination to give correct exposure, taking into account the amount of light reflecting back from the subject and the film speed.

AF
A commonly used abbreviation for automatic focusing. A small motor is used to move the lens in and out until sensors determine that the subject is sharply focused. For the system to work, the subject to be focused on often has to be located within a designated area of the camera's viewfinder.

Different methods of judging focus are used: passive systems, for example, use the fact that sharply focused images have more contrast than unsharp ones; active systems may emit infrared light or ultrasound and judge distances by the length of time it takes signals to bounce back from the subject.

Ambient light
Also known as available light, the amount of illumination naturally present: in other words, daylight or domestic lighting that has not been added specifically for the purposes of photography.

Angle of view
The amount of a scene that can be encompassed by a lens. Telephoto lenses have narrower angles of view than wide-angle lenses. For example, an extreme telephoto lens may have an angle of view of only 4°, while an extreme wide-angle, or fisheye, lens may taken in 360° and produce a circular image.

Aperture
In photography, the size of the gap formed by a series of overlapping blades set within the lens. The size of aperture can be varied to allow different amounts of light to pass through to the film and, hence, help to determine exposure. Each size of aperture is identified by its own f number.

Aperture priority
A type of AE system in which the user determines the aperture to be set and the camera selects a shutter speed to ensure correct exposure. Aperture-priority systems are most often used when depth of field is a critical factor.

ASA
A numbering system devised by the American Standards Association used to designate the light sensitivity of different film. Now superseded worldwide by the ISO system.

Automatic film advance
A motor used inside the camera that advances the film by one frame after the shutter release button is operated. The same motor is often used to wind a new film into the camera and then to rewind the film back into the cassette after the last frame has been taken.

B

Backlighting
Light coming from behind the subject and, by implication, shining into the camera lens. If a general light reading is taken, the likeliest result is a semi or full silhouette of the subject. Many cameras incorporate a backlight-compensation control, which opens the aperture up by a set amount to prevent the subject underexposing.

Barn doors
An arrangement of two or four metal flaps on a mount that fits around the front of a studio lamp. Each flap can be individually adjusted to control the spread of light from the lamp.

Bounced light
Any light that reaches the subject after being reflected from an intervening surface, such as a wall, ceiling, or reflector. This type of illumination is most often used when a soft, flattering subject light is required. Direct light can be harsh and unkind unless it is softened somehow.

Bracketing
A series of photographs given progressively more and less exposure than that recommended by the camera's light meter or a separate hand-held light meter. Photographs are usually bracketed when exposure is difficult to determine accurately and when it is absolutely critical that at least one shot of the series is accurately exposed.

B-setting
A shutter speed setting that allows the photographer to hold the shutter open manually for a longer-than-usual exposure. The shutter will remain open for as long as the shutter release is depressed. The B-setting is often used for night shots outdoors, when there is very little available light, and the camera's range of preset shutter speed settings is inadequate.

Burning in
Increasing the length of exposure of part of a print to the light from an enlarger in order to darken that part of the image.

C

Cable release
A mechanical or electronic device that allows the photographer to operate the camera's shutter via a long cable. A cable release minimizes the chance of vibrations affecting image sharpness caused by the shutter being operated in the usual way.

Cold colors
Colors from the blue-green end

of the spectrum that tend to suggest a cool atmosphere.

Color cast
An inaccurate area of color, affecting all or just part of an image. Casts may result from, for example, setting the wrong filtration on the enlarger during printing, from bouncing light from a colored surface, or from exposing film designed for daylight or artificial light to the wrong light source.

Color temperature
A system using °K (Kelvins) that differentiates between the color content of different light sources. In this system, the more orange-red the light source, the lower its color temperature; the more blue-white, the higher. Electronic flash, either studio or camera-mounted accessory flash, has the same color temperature as daylight, and so both can be used in the same shot without color casts occurring.

Compact camera
Also known as a point-and-shoot camera, a small, lightweight 35mm camera featuring a direct-vision viewfinder, a non-removable lens, and, usually, a high degree of automation.

Contact sheet
A series of pictures the same size as the film original, used to judge which pictures to enlarge.

Contrast
The difference in brightness between the deepest shadows and the brightest highlights of a scene. If the range of contrast is too great, film may be incapable of recording subject details in both extremes.

Contre-jour
Another term for backlighting.

Cropping
Enlarging or selectively printing an image to omit unwanted parts of the subject. Cropping also refers to the framing judgements made by the photographer at the time of taking the picture that determine what will be included in the picture and what will not.

D

Daylight-balanced film
Color film that has been specifically designed to be exposed in daylight or by light from electronic flash. If exposed to artificial light sources such as domestic or studio tungsten, color casts will result.

Dedicated flash
A type of accessory flash system dedicated to a particular camera, or range of cameras from the same manufacturer. Once fitted into the camera's hot shoe, or connected to the camera by a special cable, it becomes an integral part of the camera's electronic system. By monitoring the amount of light from the subject received by the film, the flash varies its light output to ensure correct exposure.

Depth of field
The area of acceptably sharp focus in front of and behind the point of true focus. Depth of field varies depending on the aperture used (small apertures have greater depth of field than large ones); the lens focal length (telephoto lenses have less depth of field at any given aperture than wide-angle lenses); and focus distance (depth of field increases at any given aperture the further away from the camera the lens is focused).

Diffuser
Any translucent material used in front of a light to spread (or scatter) and, thus, soften the quality of the illumination.

Dodging
Decreasing the length of exposure given to part of a print in order to lighten that specific part of the image.

DX coding
A way of marking a film cassette so that the film speed can be read and then automatically set by the camera.

E

Emulsion
The microscopically thin coating on film or printing paper composed of light-sensitive crystals evenly suspended in a gelatin carrier medium. It is the emulsion that forms and carries the film or paper image.

Existing light
Another term for available light.

Exposure
The amount of light received by a camera film or a piece of printing paper. The amount of exposure is the result of the length of time the light is allowed to act on the film or paper (controlled in a camera by the shutter speed) and the intensity of the light (controlled by the lens aperture). By doubling the length of time the light acts on the film or paper emulsion and halving the intensity, the same overall exposure results.

Exposure latitude
The range of lighting intensities present in the same scene a film is capable of recording while retaining an acceptable degree of subject detail.

Exposure meter
Also known as a light meter, a device, inside the camera (with an SLR), on the front of the camera (with a compact), or a separate hand-held unit that measures the light reflected from the subject. The light striking the meter is converted into a recommended aperture and shutter speed combination to give correct exposure. On a automatic camera, the aperture and shutter speed are set directly.

F

Fill-in light
A subsidiary light used specifically to lighten the shadow areas of a subject.

Film speed
Refers to the light sensitivity of a photographic film emulsion. All film is given an internationally agreed ISO number that denotes its speed. Fast films (such as ISO 400 and above) are more light sensitive than slow films (up to ISO 200).

Fisheye lens
A type of wide-angle lens that produces a 360°, or near 360°, view of the subject or scene. Some produce a circular image.

Fixed focal length
A type of lens with a single, fixed focal length – such as 28mm, 50mm, or 135mm – as opposed to a zoom lens that has variable focal length settings.

Flash synchronization
A shutter speed setting that ensures that the shutter is fully open, and the film frame completely unobscured, when the flash fires. On some cameras there is a lightning bolt symbol to denote the correct flash synchronization setting to select; on others, the correct shutter speed to use is picked out in red; while on others, a whole range of shutter speeds can be used.

Floodlight
A type of studio light that produces a broad spread of illumination. Used for general lighting effects, often in conjunction with more focused light sources.

F numbers
Also known as f stops, a series of numbers found on the lens barrel used to denote the size of the aperture. A common range of lens apertures is: f1.4, 2, 2.8, 4, 5.6, 8, 11, 16, 22. Each time you select the next smallest aperture number (for example, changing from f5.6 to f4) you double the area of the aperture and, thus, allow twice as much light to reach the film. Moving the aperture control the other way (from, say, f11 to f16) you halve the area of the aperture and, thus, halve the amount of light reaching the film. Small apertures (denoted by large aperture numbers) are associated with a greater depth of field than large apertures (denoted by small aperture numbers).

Format
The size and shape of a particular type of film or camera. For example, the 35mm format refers both to the camera and the type of film it accepts.

Frame
A single exposure on a roll of film. The term is also used to refer to boundaries of the picture-taking area seen through the camera's viewfinder, or to any compositional device used to surround or otherwise emphasize or set-off the main subject.

Frame advance
An automatic feature on most compacts and many SLRs that advances the film one frame after each exposure.

F stop
Another term for f number.

G

Grade
Refers to the ability of black and white printing paper to distinguish between different shades of gray.

Graininess
The visual appearance of the clumps of light-sensitive crystals that make up a film emulsion. In general, graininess becomes more apparent as film speed increases and as the size of the enlargement (or projected transparency) increases.

Guide number
Often abbreviated to GN, a figure denoting the light output of a flash. The guide number is often quoted in both feet and meters, and dividing the GN by the subject distance from the flash gives the aperture to be set for correct exposure (for ISO 100 film). With the introduction of reliable computer-controlled flashguns, which automatically adjust their light output to suit the subject, GNs are now often not needed for calculating correct flash exposure.

H

High key
A type of lighting effect that produces an image composed predominantly of light tones and or colors. It is possible to accentuate the high-key potential of an image through slight overexposure.

Highlights
The brightest parts of an image. If the exposure difference between the brightest highlights and the deepest shadows of an image are too great, the film may not be able to record subject details in both.

Holding back
Another term for dodging.

Hot shoe
A fitting found on the top plate of many cameras that accepts the shaped foot of a flashgun. Electrical contacts on the base of the hot shoe automatically fire the flash when the shutter is depressed.

Hot spot
An unwanted bright reflection in an image. A hot spot is often caused when light strikes a glass or highly polished surface. Less intense but extremely distracting hot spots can also be caused when light reflects back from a shiny area of skin on your subject's face, forehead, or bald head.

I

ISO
A numbering system devised by the International Standards Organization used to designate the light sensitivity of different film. This system has now superseded the former ASA numbering system. A doubling of ISO number indicates a doubling of film speed – for example, ISO 200 film has twice the light sensitivity as ISO 100 film.

Incident light
The light falling on, as opposed to reflected from, an object or surface.

Infinity
A lens focus setting (often denoted by the symbol ∞) used to bring distant objects into sharp focus.

K

Kelvin
A unit of measurement for the color temperature of light.

L

Lens speed
Refers to the maximum available aperture of a particular lens. Lenses with a wide maximum aperture – say, f1.2 on a standard lens or f2.8 on a moderate telephoto – are said to be fast. Fast lenses allow a wider range of aperture/shutter speed combinations to be used in varying light conditions, and with an SLR they also produce a brighter viewfinder image.

Long-focus lens
On a 35mm format camera, a lens with a focal length greater than 50mm. When referring to modern lenses, the term (in nearly all circumstances) can be used interchangeably with telephoto lens.

Low key
A type of lighting effect that produces an image composed predominantly of dark tones and or colors. It is possible to accentuate the low-key potential of an image through slight underexposure.

M

Maximum aperture
The widest aperture available on a particular lens.

Minimum aperture
The smallest aperture available on a particular lens.

Mirror lens
A type of telephoto lens that uses mirrors instead of some of the traditional lens elements to bounce light from the subject up and down within the lens. This allows a very long focal length to be accommodated in a physically short (and relatively lightweight) lens barrel.

Mode
Any of a number of automatic exposure systems that may be available on a camera – for example, aperture priority, shutter priority, fully automatic, and so on. Compacts are most often fully automatic, while SLRs and medium format camera may have a choice of modes.

Motor drive
A motor that advances the film continuously as long as the shutter is depressed. A motor drive is typically able to take up to 5 frames per second, depending on shutter speed.

Multiple exposure
Recording two or more images on the same frame of film or printing paper. Camera systems normally prevent accidental double exposure by disengaging the shutter release until the film has been advanced to the next unexposed frame. However, some cameras allow double exposures to be made as a special effect.

N O

Negative
A developed film image in which (with black and white film) subject highlights are seen as dark tones and subject shadows as light tones, or (with color film) subject colors are recorded as their complementaries.

Normal lens
A lens with a focal length that is approximately equal to the diagonal of its film format. Such a lens produces an image that approximates to the scene as it is viewed with the naked eye. On a 35mm camera, this is a 50-55mm lens; on a medium format camera, about 80mm. Also known as a standard lens.

Overexposure
A pale, light image resulting from allowing too much light to reach the film. All highlights are very bright and subject detail is present only in the shadow areas.

P

Panning
Swinging the camera in an arc to keep pace with a moving subject while the shutter is open and the film is being exposed. This results, ideally, in a sharply recorded subject seen against a blurred background

Pentaprism
The five-sided prism shape seen on the top of SLR cameras. The inside surfaces are mirrored to reflect the image produced by the lens. The result is that the image appears in the viewfinder as upright and correctly oriented left to right.

Perspective
Implying depth and distance in a two-dimensional photograph. Typical forms of perspective are parallel lines that appear to converge as they recede; differences in scale between near and far objects; overlapping forms; and a lightening of tone (or a blue color cast) in distant scenes.

S T

Shutter priority
A type of AE system in which the user sets the shutter speed and the camera selects an aperture to ensure correct exposure. Shutter-priority systems are most often used when controlling how subject movement is recorded is a critical factor.

Single lens reflex (SLR)
A type of camera that uses an angled mirror inside the body to reflect the image from the lens up into the viewfinder. With this viewing system, you always see precisely the image produced by lens, no matter which lens (or zoom setting) is being used.

Snoot
A conical-shaped studio lighting attachment that confines light output to a small circular area.

Tungsten light-balanced film
Color film designed to be exposed in tungsten light. If exposed to daylight or flash, color casts will result.

U W

Underexposure
A dark image resulting from allowing too little light to reach the film. All shadows are very dense and subject detail is present only in the highlights.

Warm colors
Colors from the orange-red end of the spectrum that tend to suggest a brightness and warmth.

Index

Acknowledgments

I would like to thank all the models that helped in the making of this book. Many thanks, too, to Jennifer Hogg and Elaine.

Special thanks go to Dave Crook and Auberon Hedgecoe for the computer image manipulations on pages 136-146 and Phil Kay for the computer image manipulations on page 147.

I would also like to thank all the organizations who contributed to the production of the book, especially to the manufacturers and distributors of the camera and lighting equipment featured on pages 148-151.

All illustrations in this book were drawn by David Ashby.